FISHING ON THE TERRACE

鉤竿青竹長
江淺幽思深莫
話朝与市不能
諧素心

沈周

FISHING ON THE TERRACE

A Collection of Writings by Mary Mayer Tanenbaum

Edited by Heather Parks

To the memory and spirit of Mary Mayer Tanenbaum
who made art out of words

Copyright © 2018 by the Mary M. Tanenbaum Foundation

Published by Stanford University Libraries

Printed in Canada

Cataloging-in-Publication Data is available at the Library of Congress
ISBN 978-0-9112-2158-9 (cloth)
ISBN 978-0-9112-2120-6 (e-book)

Editor: Heather Parks
Designer: Ellen Nygaard

PAGE 1: QI BASHI, HUANG BINHONG, AND FRIENDS
Presentation Album 1938–1940
China
Ink and color on paper
12 x 7¼ x 1¾ in. (album), 12 x 13⅞ in. (each painting)
The Mary M. Tanenbaum '36 Collection
Courtesy the Iris & B. Gerald Cantor Center for
Visual Arts at Stanford University

PAGES 2–3: SHEN ZHOU
Album of Twelve Landscape Paintings
China, ca. 1500
Ink and color on paper
12¾ x 23 in.
The Mary M. Tanenbaum '36 Collection (2004.131)
Courtesy the Iris & B. Gerald Cantor Center for
Visual Arts at Stanford University

PAGE 5: QIU YING
Fisherman's Flute Heard over the Lake (detail)
China, Ming dynasty (1368–1644)
Hanging scroll; ink and light color on paper
62⅞ x 33⅛ in.
The Nelson-Atkins Museum of Art, Kansas City,
Missouri, Gift of John M. Crawford Jr., in honor
of the Fiftieth Anniversary of the Nelson-Atkins
Museum of Art (F82-34)

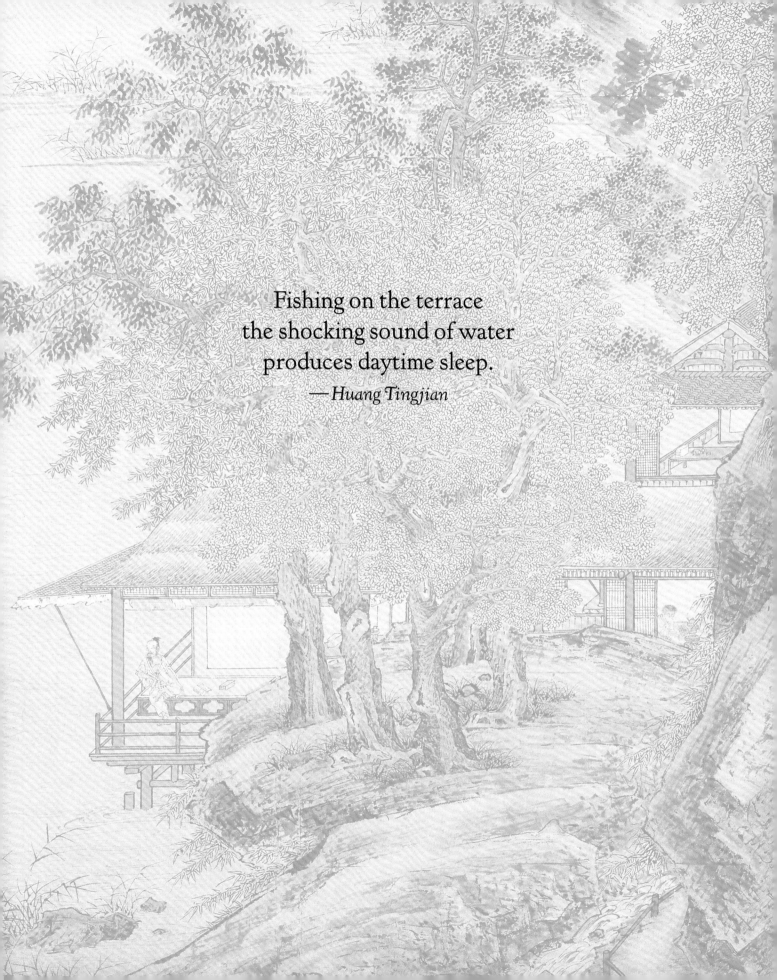

Fishing on the terrace
the shocking sound of water
produces daytime sleep.
— *Huang Tingjian*

Contents

WEN ZHENGMING
Enjoying the Waterfall (detail)
China, 16th century
Ink and color on paper
12½ x 421 in.
The Mary M. Tanenbaum '36 Collection
Courtesy the Iris & B. Gerald Cantor Center
for Visual Arts at Stanford University

THE FAR VIEW

THE PLACES IN BETWEEN

Appreciation

Upon reading Mary Mayer Tanenbaum's essays and articles, gathered in this book, I feel renewed regret for not having known her better during her lifetime. Mrs. Tanenbaum and I met only once, not long before she passed away. The subtly informed and sensitive taste Mary had cultivated over the six decades of her marriage with Charles Tanenbaum was perfectly evident on the walls and the flat surfaces of the home she and Charles created in a Park Avenue apartment in New York City. In that one visit, my attention was drawn to the works of art— Chinese paintings on scrolls and other large-format paper as well as numerous sculpted pieces and objets d'art. It was a scrumptious introduction to the collection she had so carefully amassed.

The essays Mary Tanenbaum composed and are now assembled in this book are deeply informed by Mary's own appreciation of Chinese history and the various influences of that history on the artistic expressions of the long period of the Six Dynasties. I particularly recommend the opening essay here, "The Views," for Mary's elucidation of the near view / far view dichotomy and its relevance to her own life and responsibilities, which she modestly expresses as her garden. How exquisite and careful, yet so poignant, are her thoughts. Please notice also the pairing of images from the Mary M. Tanenbaum '36 Collection of the Iris and B. Gerald Cantor Center for the Visual Arts at Stanford University with her essays, such as the Shen Zhou image from the Album of Twelve Landscapes preceding "The Views." Ann Tanenbaum, the estimable daughter of Mary and Charles, and editor Heather Parks deserve accolades for their own editorial and artistic acumen, which is on display throughout *Fishing on the Terrace*.

The essay "Journey to the East: The People's Republic of China" relates the skein of Mary's adventure in what must have been in 1979 or the early 1980s to the PRC, the implied persuasiveness of her intentions to collect well AND to engage in cultural exploration as well as her own inner journey of an expanding connoisseurship informed by both her collecting and the lessons of her travels.

There are important lessons to be learned from the essays collected in this volume. Perhaps the most important is that of pursuing the life of the mind throughout one's lifetime—exploring, learning, expressing one's ideas clearly and precisely. The continuous development of one's senses, sensibilities, cognitive and expressive capacities is the hallmark of an intellectual, and indeed a much needed characteristic in our era of overemphasis on the superficial. Another lesson found here is that of modesty. Mary Tanenbaum's descriptions of and musings upon cultural objects and their social and historical contexts do not magnify her personal involvement, leaving that only mildly reported, almost as though she were a third party observing at some remove. The combination of that modesty with a lifetime's journey of intellectual and expressive growth should be emulated, for while our own lives are relatively short, our ideas and insights, our collections of artifacts, and the experiences we have gleaned from them and described live on for the benefit of others who come after us.

We are pleased and proud to have assisted in passing on to readers far and near in time and distance Mary Mayer Tanenbaum's life's work through this anthology of her writings.

Michael A. Keller
University Librarian and Publisher of the
Stanford University Press

Man under Tree (line drawing)
Bookplate
Mary M. Tanenbaum Fund, Stanford University Libraries
Artist: Leslie Tseng-Tseng Yu

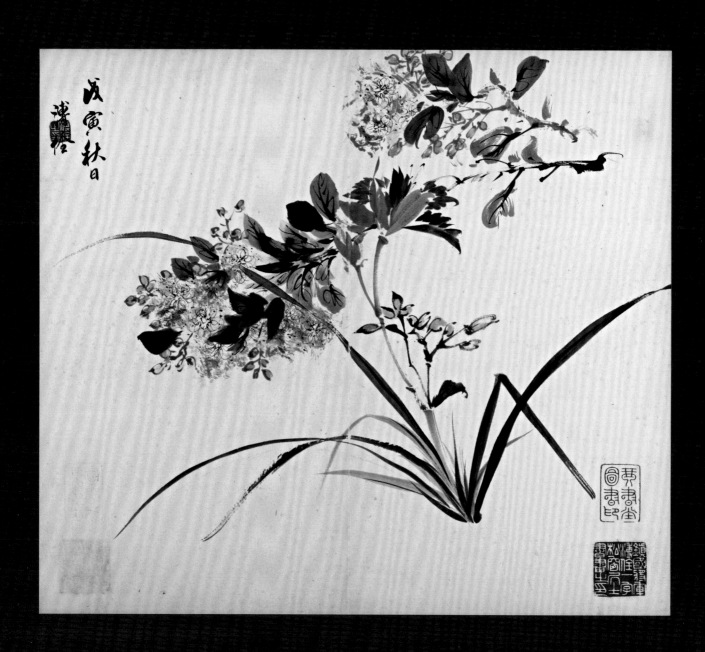

Appreciation

One of the wonderful things about being the director of the Cantor Arts Center is that I get to know both the art and people that make this place so special. There's no doubt that Mary Mayer and Charles Tanenbaum are two people whose commitment to art and the art world has left a lasting impression here.

Every year, hundreds of Stanford students come to the beautiful Tanenbaum Seminar Room, a space designed to provide access to art for research and to supplement coursework being done in the arts. For many students, the Tanenbaum classroom is where they begin forging their personal relationships with art and experiencing the joy of seeing a work of art up close.

In reading Mary's writing and coming to appreciate her collection, I was struck by the concepts she explores of the "near view" and the "far view." She notes that in the Chinese art she collected throughout her life, these two polarities existed together. Some artists portrayed the "far view," often represented by rugged mountains and flowing rivers, while others focused on the "near view," with lakes and hills replacing the rivers and mountains. Mary writes that she found herself drawn to the "near view," the small-scale scenes of life and natural beauty. For her, many of those moments of connection came in her beautiful and beloved garden.

The works that Mary collected featuring colored inks on fine papers are particularly expressive. And the way

Mary paired her own stories with these works of art, blending old with new, is a wonderful example of how a new art form can illuminate the stories and deep reflections arising from the encounter between the distant and the familiar.

I believe that many Cantor Arts Center visitors come to experience their own "near view." Some visitors may be drawn to a particular painting, print, or sculpture and may stand for many minutes before it, lost in contemplation. Others may be drawn to the natural beauty of the setting and enjoy strolling through the sculpture garden. Like Mary, they're finding their place in the world, using art to help them.

We hope readers will be inspired, as we are, by Mary's intellectual curiosity, her passion for making art relevant, and her desire to learn from and expose others to art from different cultures. But even more, we hope readers will be moved by Mary's ability to integrate the art of a distant land into her own, thereby encouraging us to find our own meaningful connections to art, especially in the "near view" of our daily lives.

Susan Dackerman
John and Jill Freidenrich Director
Iris & B. Gerald Cantor Center for Visual Arts
at Stanford University

QI BASHI, HUANG BINHONG, AND FRIENDS, *Presentation Album 1938–1940,* China. Ink and color on paper, 12 x 7¼ x 1¾ in. (album), 12 x 13⅞ in. (each painting). The Mary M. Tanenbaum '36 Collection Courtesy the Iris & B. Gerald Cantor Center for Visual Arts at Stanford University

Personal Reflections:
A DAUGHTER ON HER MOTHER

Ann Tanenbaum

I love my mother and feel great pride in her and the life that she led. As a collector of Chinese art, she possessed an extraordinary eye and cultivated a deep knowledge of her subject. She was a wise and graceful writer, a winning tennis champion, and a cultivator of lasting friendships. She was also beautiful, captivating, and unforgettable.

My childhood friends described my mother as "glamorous and exciting." She was the only woman we schoolchildren knew who had an identity and role beyond the idealized motherhood of the 1950s.

On rainy days, Mom would pick me up from the grammar school I attended and we would relish Cantonese lunch at her favorite restaurant, Tommy Chen's, in nearby White Plains, New York. Instead of reserving under the name Mary Tanenbaum, Mom made our reservation in her chosen Chinese name, Mary Tan.

When adopting this name, Mom would morph into something akin to the butterfly, a creature she so admired in art. As she writes in "The Symbol of Summer" (see p. 43), "May I not learn to see myself, like the butterfly, as naturalized, as enveloped, within the grand design of nature?" As Mary Tan, she spoke with comfort and distinction on her favorite subjects: Chinese art, nature, and philosophy. It was fascinating to observe the very naturalness in her that she so admired in nature.

The concept of all-encompassing nature juxtaposed with the finitude of man captivated Mom's creativity. The strong, resolute pine tree, the serene lotus, the lasting patience of the chrysanthemum, and the harmony within her garden were an inspiration to her. She found in Chinese philosophical teachings and reflections an infinite peace.

On February 6, 1996, while at home in San Francisco, my mother suffered a powerful stroke. With her health and bonhomie grievously challenged, she behaved with courage and grace. Mom seemed to inhale the strength of her trusted bamboo. It allowed her to bend endlessly without breaking, until the very end.

For me, of course, my mother will always be alive. Her irresistible smile stays with me. Her most beloved acquisition—the late fifth-century to early sixth-century Northern Wei Buddha she discusses so delightfully in "Journey to the East: The People's Republic of China" (see p. 63)—now resides in a university museum that I visit often. During my mother's lifetime, it graced the mantle of every home our family shared. With immense gratitude, I now share my own home with a treasured selection of Mom's handscrolls, bronzes, jade, porcelain, and mounted screens, which remind me of everything wonderful about her. Mom's endless fascination with the world, her wisdom, and her love suffuse the pages of this book.

I am endlessly grateful to Michael A. Keller for publishing *Fishing on the Terrace*, a selection of Mom's journalistic writings, under the imprint of Stanford University Libraries, to Heather Parks for sensitively curating this volume, and to Ellen Nygaard for giving the material its beautiful form. Altogether this volume is true to Mom's sensibility. She would be so very happy knowing that this dream of hers has become a reality.

Mary Mayer Tanenbaum

Introduction

Heather Parks

How often is it that someone can put into words the connection one feels between an extraordinary work of art and those mundane moments of life that seem to pass altogether too quickly? To take this question further, how many are able to do so when the art in question was created centuries ago and based on an ancient system of philosophy not generally practiced, or understood, by the majority of one's peers? The answer, generally, is very few.

Mary Mayer Tanenbaum's great gift was to be able to connect the quotidian moments of an afternoon's reverie to the universal principles addressed in Daoism, as expressed in Chinese art, primarily in the specific art of landscape painting. She found in this art metaphors for the oppositional play of forces in a small waterfall jumping over stones, as observed in her garden; elements arranged to reflect the polarity of contrasting views, such as she noted in her travels; and finally the anthropomorphic qualities of natural materials that allowed a simple branch of bamboo to say so much more. Mary asked questions, made comparisons, and kept an open mind as the world of art wove its spell around her days. She then recorded her thoughts, paired them with the piece of art that most inspired them, and made the marriage of the two available to her readers.

I came across Mary Mayer Tanenbaum's writings by a happy accident that has much to do with a passion she and I share: a persistent fascination with culture beyond the shores of the country to which we were born. Unlike Mary, whose meandering walks through San Francisco's Chinatown informed her interest in Chinese art and thought, I developed my intellectual wanderlust during long hours in the Maryland library where I spent much of my childhood. The type of writing that Mary dedicated herself to producing—articles about art, culture, and philosophy— was a salvation to me as a child growing up in a small town.

My early exposure to the writing of women whose interior lives intersected with the worlds of art and culture has significantly shaped the way that I interact with the world. It was the legacy of these books—my own penchant for traveling and writing—that led to the happy accident of early 2014, when a dear friend and sometime traveling companion introduced me to Ann Tanenbaum, Mary's daughter.

I soon found myself, on the occasion of one of my initial meetings with Ann, kneeling on the floor in front of a large traveling trunk in her lovely Upper East Side apartment and poring over Mary's working drafts, travel journals, and letters. Immediately I felt a spark of kinship with this prolific writer and her nuanced voice.

In stark contrast to Mary's more formal autobiographical essays, which were intended for publication, her journals, most of which were composed while traveling, offered seemingly endless reflections. The enthusiastic jottings that filled their pages belied the calm reportage culled in a trip's aftermath. Her marginalia suggest that Mary was a passionate seer of places, things, and people, with an unquenchable thirst for experience and knowledge.

Corners of Mary's life that were otherwise unknowable—her Westchester garden, an art dealer's room on the Upper East Side from which she made her very first purchase as a collector—drew me in and convinced me that Mary's writing was both ahead of its time and much deserving of a wider audience.

It was one of Mary's great wishes to have the numerous articles she had written for the *Christian Science Monitor* published in one volume. The timing for such a collection is indeed felicitous, for writings that espouse the return to a simpler, more harmonious relationship with nature as a way to explore one's self are well suited to today's world, in which movements toward greater self-reflection and emphasis on a return to the earth have gained a good many adherents.

Mary's daughter, Ann, recognized this and, with a tenacity that echoes that of her mother, supported the publication of this book every step of the way. In giving

me access to her mother's writing memorabilia and through personal recollection, Ann proved an invaluable resource as I strove to derive a multifaceted view of a woman I would never meet. In addition to the time Ann spent with me in conversation, she worked tirelessly behind the scenes in tandem with Stanford University Libraries to bring *Fishing on the Terrace* to press. Her commitment to fulfilling Mary's vision never flagged, and I am eternally grateful to Ann for her humor, support, and guidance through the lengthy process of bringing this book to print.

Mary left many thoughts on how best to organize a collection of her writing. Her clearest wish seemed to be that the book present a compendium of her articles for the *Monitor*, with the writing alongside the art that accompanied it when originally published. The question of how to group the articles, however, was a source of conflicting editorial ideas, all of which circled around finding a method to foreground the tenets of Chinese thought or philosophy that Mary explores.

Ultimately, I discovered that Mary's article "The Views," which opens this volume, provides a framework that neatly incorporates both art and philosophy. It offers a broad sense of what the best of Mary's work conveys: all that can be gleaned from the two perspectives of the near versus the far. We see these concepts explored in the sections devoted to them: The Near View and The Far View. According to Mary, they exist necessarily to illuminate a third realm, the "places in between," the things that link us inextricably together. These are the focus of the final section. The articles chosen for inclusion in the volume you hold today all broadly fall within these rubrics.

As stated previously, it was Mary's great talent to uncover these places. She touches on the fundamentals of what it means to exist both as part of the natural world and as an observer of that same world. Perhaps this is one definition of "humanity," our human capacity and propensity for duality, especially the ability to observe one's self while inhabiting one's self. One of the tenets of Confucianism, which Mary would have been very familiar with, rests on the belief that this observing self is fundamentally good and perfectible through self-cultivation. Mary's articles are an invitation to readers to take time from busy schedules and engage in the act of self-creation through the filters of nature and of art.

In venerating Chinese art, Mary primarily gravitated toward landscape paintings and scenes from nature that date roughly from the Tang dynasty (618–907CE) through the end of the Republic Period in 1949. There are, as you will notice, very few exceptions to this rule in the art that accompanies her articles here. When exceptions do occur, they do so mainly to link the artistic traditions of contemporary artists to traditions of the past.

It might prove tempting to put Mary's writing in a historical context. In particular, one might consider the dates during which she was actively publishing. The Cultural Revolution, which took place in the People's Republic of China from 1966 to 1976, was winding to a close as Mary delivered her first article to Henrietta Buckmaster for the *Christian Science Monitor*'s Home Forum in 1975. In stark contrast to Mary's effort to link both Chinese landscape painting and Daoism with the contemporary world, the Cultural Revolution, set into motion by Mao Zedong, had the stated goal of promoting Communist ideology by targeting for subversion certain traditional elements of Chinese society and culture. Cultural sites and historical relics were being destroyed in China at the same time that Mary set out to preserve their importance in a popular American newspaper.

Mary herself, however, doesn't state anything either in her published writings or anecdotally to suggest that her articles were in any way meant to challenge Chinese political trends of the time. Instead, they are approaches to timeless treasures that take contemporary surroundings and trends into account.

In each selection for this volume, I sought to preserve the relationship between article and artwork as it was originally presented in the *Monitor*. However, there were a few instances where this proved impossible. Some images have been lost to time and circumstance. In these cases, I selected accompanying artwork based on what I perceived to be Mary's intention with the original pairing, be it to illustrate a certain concept, painter, or style.

By the time Mary wrote her final article for the *Christian Science Monitor* in 1984, she would have visited the People's Republic of China herself, as well as formed an important collection of Chinese artifacts and paintings, some of which are discussed in her work. These items would go on, after her death, to inspire scholars and admirers, who are able to access them via the institutions, such as the Iris and Be. Gerald Cantor Center for Visual Arts at Stanford University, to which they were left.

The publication of this book was a dream that Mary Tanenbaum pursued throughout her writing life. We are so pleased to share the fruition of that dream with you, her readers.

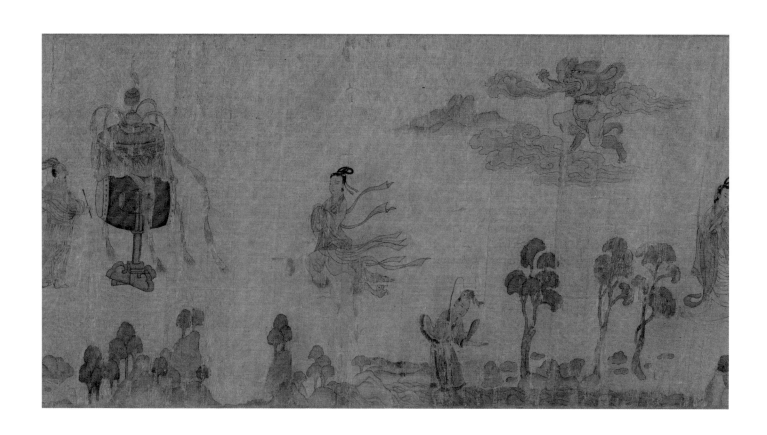

GU KAIZHI
Nymph of the Luo River
China, Southern Song dynasty (1127–1279)
Ink and color on silk
9½ x 122⅜ in.
Freer Gallery of Art, Smithsonian Institution,
Washington, D.C., Gift of Charles Lang Freer (F1914.53)

Daoism and Traditional Chinese Art
AN OVERVIEW

Jidong Yang

One of the major philosophical and religious traditions of China, Daoism (also spelled Taoism) has its historical roots in the precommon era of more than two thousand years ago. The Chinese word *dao* means "road" or "path" and is often translated into English as "the Way." Unlike the major religions imported from outside into China such as Buddhism, Zoroastrianism, and Christianity, Daoism is generally considered indigenous to Chinese civilization, though it also bears clear influences from foreign cultures.

The origin of Daoism is often traced back to the written works of Laozi (or Lao-tzu) and Zhuangzi (or Chuang-tzu), two master-thinkers who lived in ancient China before the third century BCE. In his *Dao de jing* (*Scripture of Dao and Virtue*), one of the most influential classical texts in Chinese history, Laozi defines "the Way" as something that existed even before the formation of Heaven and Earth. It is invisible but powerful, simple but ideal, humble but harmonious, constituting the source of all forms in the world. Living in a chaotic period of endless wars and disorders, Laozi appeals for a "return" to the original and natural way of life by abolishing desires. He argues that "inaction" (*wuwei*), or letting things run their natural course, is the best attitude human beings can take towards all things and matters. About a century later, Laozi's philosophy was further developed by Zhuangzi in a book that bears his name, the *Zhuangzi*. The book established the status of Daoism as one of the mainstream ideologies in ancient China, along with such schools as Confucianism and Legalism. Unlike the *Dao de jing,* which was intended for

the ruler to read, the *Zhuangzi* was the first Chinese work to present a philosophy for private life and was a masterpiece in the history of Chinese literature. Using anecdotes, parables, and dialogues, the *Zhuangzi* asks people to free themselves from various binds by the method of inaction.

Another important source of Daoism was the cosmology developed by the School of Naturalists (also known as the School of Yin and Yang), which was founded by Zou Yan, a contemporary of Zhuangzi. The most famous concepts established by this school included yin (dark, cold, negative, passive, female) and yang (light, hot, positive, active, male), the two opposing qualities or powers that can be found in all things, and in all lives. The Five Elements (*Wuxing*), namely wood, fire, earth, metal, and water, is another group of concepts heavily used by the Naturalists and later absorbed by Daoism.

After the unification of China under the Qin dynasty in the late third century BCE, Daoist philosophy survived the large-scale political persecution launched by Emperor Shihuang against all ideological schools but Legalism. Entering the Han dynasty, while Confucianism was adopted by Emperor Wu as the official ideology, Daoism continued to thrive among the educated class. In the late second century CE, it became an organized religion under the leadership of Zhang Daoling. During the several centuries that followed, Daoism expanded its influence thanks to the sponsorship of many Chinese rulers. Quite a few Tang dynasty emperors, for example, vigorously promoted Daoism and claimed Laozi as the imperial house's ancestor. After Buddhism was introduced to China, only

to become a major competitor with Daoism, both religions underwent numerous changes and learned from each other in many areas including pantheon organization, institutional structure, canon compilation, ritual system, and temple architecture. Having lasted for more than two thousand years, Daoism today is still one of the five religions officially recognized by the Chinese government, with numerous temples and followers in the Chinese-speaking world.

Daoism has had an enduring and profound impact on traditional Chinese art, especially on such genres as painting and calligraphy. In fact, most art historians agree that Daoism played a bigger role in the development of Chinese art than any other ideological system. The reason was pretty simple: Daoism provided the most satisfying spiritual experience for Chinese intellectuals, many of whom were artists themselves. In the Daoist doctrines of returning to the original and primitive condition, pursuing a simple life, achieving a harmonious balance between nature and humans, and freeing oneself from social bounds, premodern Chinese elites found an escape from a world filled with struggles and tensions. Century after century, they tried to visualize this ideal world with their brushes and ink.

The origin of landscape painting in medieval China was directly associated with the Daoist movement of the time. During the historical period called the Six Dynasties (220–589), a large number of Chinese elites, especially those living in the south, pursued "dark learning," a school of philosophy that was developed under the influence of Daoism and is often referred to by modern scholars as Neo-Daoism. Gu Kaizhi, one of the leaders of the school and a devoted Daoist, is widely credited with the foundation of landscape painting in China. His famous scroll painting *Nymph of the Luo River* contains numerous mountains, trees, and water in green color. Although nature serves only as a setting for human stories in this scroll, the techniques Gu used to represent it were inherited by many generations of Chinese artists. He also wrote some of the earliest Chinese treatises on creative art. In his "On Painting," Gu applies Daoist criteria such as "natural" (*ziran*) and "rich in raw energy" (*shengqi*) to comment on contemporary artworks. Wang Xizhi, the greatest calligrapher in Chinese history and a contemporary of Gu Kaizhi, was also a Neo-Daoist. One of his best-known works was a copy of the *Book of the Yellow Court*, an important text in the Daoist canon.

During the Six Dynasties, Daoism and Buddhism were competing with and influencing each other at the same time. Some Chinese intellectuals had become adherents of the new religion imported from Central Asia and India, but that did not prevent them from being continuously obsessed with Daoist thinking. Just like most ordinary Chinese people of the time, who did not have a clear distinction between Buddhism and Daoism, educated elites often treated the two as peacefully coexisting and mutually supplementary beliefs. A good example was Zong Bing, who laid the theoretical foundation for landscape painting in China. He was a lay disciple of the great Buddhist Huiyuan, but his famous essay *On the Painting of Mountains and Water* drew heavily from Daoist philosophy and terminology. Refusing to serve for the government, Zong secluded himself from the world and lived in deep mountains for thirty years, practicing the Daoist way of life. In his essay, he argues that artists can attain spiritual elevation through landscape painting. He also feels that communing with nature is a way to commune with the souls of sages who had been inspired by the same mountains and rivers in the past. After Zong Bing, nature in the forms of mountains and water became a central element of traditional Chinese art. For more than a thousand years, Chinese painters have expressed Daoist philosophy by visualizing nature.

Early in the Tang dynasty (618–907), Daoism became the official ideology and flourished. Daoist temples were established all over the country, even in remote places such as Dunhuang on the Silk Road, where Buddhist influence used to be predominant. The construction and decoration of those temples created a huge demand for Daoist artworks. Although none of them have survived to this day, mural paintings depicting the Daoist pantheon and landscape were a popular scene in those religious facilities. Historical records show that some leading artists such as Yan Liben and Wu Daozi were actively engaged in decorating Daoist temples. In addition to contributing artworks for religious use, many Tang elites continued to compose paintings on Daoist themes for private purposes. An imperial painting catalog compiled about two hundred years after the end of the Tang records a large number of Daoist paintings from that dynasty.

The emperors of the Song dynasty (960–1279) were also known for their devotion to Daoism. Emperor Huizong even gave himself the title "Lord of the Dao." He was the greatest painter and calligrapher among all Chinese rulers, leaving behind quite a few masterpieces of traditional Chinese art, one of which, *Finches and*

Bamboo, can be seen in this volume alongside the article "Painting Is Poetry." His paintings and calligraphies display a deep understanding of the Daoist philosophy. He also founded the first art academy in Chinese history, focusing on training young painters. Daoist scriptures were required readings for all students in the academy, where Huizong often taught classes and gave tests himself. Some of the themes he gave students to paint show strong Daoist characteristics, such as "a lonely and empty ferry boat in a wild river," and "an old temple hidden in rough mountains." Under his patronage, Daoism quickly became the most important source of imagination for Chinese artists. Meanwhile, landscape painting became the mainstream and the most favored art form among the educated class. Unlike the Tang dynasty which left behind few landscape paintings surviving to this day, many of the Song masters' works, such as those of Li Cheng, Fan Kuan, Guo Xi, Li Tang, Liu Songnian, Ma Yuan, and Xia Gui, can still be found in museums around today's world.

Another important genre of traditional Chinese art, the so-called literati painting, also emerged during the Song period under the influence of Daoist aesthetics. Just like reading classics and composing poems, painting became a common practice among the Chinese literati of the time. Characterized by small canvas size, monochrome (black ink), and relatively simple composition, literati paintings are more abstract than most other Chinese paintings. The genre's representative artists in the Song dynasty, such as Wen Tong, Su Shi, Mi Fei, and Mi Youren, were all well versed in Daoist philosophy. Some of their surviving artworks have motifs directly developed from the classical texts written by Laozi and Zhuangzi.

In the late thirteenth century, the Mongolians conquered the Song and established the Yuan dynasty (1271–1368). Even before they became the rulers of China, the Mongolian royal family learned enthusiastically about Daoism. Qiu Chuji, the greatest leader of the Daoist community in north China, was invited to the Mongolian court to serve as Genghis Khan's advisor. After the Yuan dynasty unified China, Daoist religion and philosophy continued to thrive throughout the country. Most Chinese artists of the time considered themselves Daoists. Although the Yuan was a relatively short-lived regime, lasting for only about a century, it is known for a huge output of monumental artworks, many of which are still inspiring audiences all over the world. Gao Kegong, Zhao Mengfu, Huang Gongwang, Wu Zhen, Ni Zan, and Wang Meng are all well-known figures in the history of Chinese art. Most of them refused to serve in the Yuan government and lived in seclusion. Through their landscape and literati paintings, these masters expressed Daoist values such as respecting nature, pursuing originality, and purifying spirit. In addition to the artwork of the elite class, mural paintings in Daoist temples had also reached a new height. Today's visitors to the Eternal Joy Temple located at Ruicheng County, Shanxi Province, for example, are immediately stunned by the large-scale and extremely colorful wall paintings of Daoist gods and deities dating from the Yuan dynasty.

The Yuan was followed by the Ming dynasty (1368–1644), another important period in the history of Chinese art. Neo-Confucianism, a new form of Confucianism that was created during the Tang-Song period after absorbing much influence from both Daoism and Buddhism, was established by the Ming rulers as the state-endorsed ideology. But Daoism remained the primary source of inspiration for most Chinese painters. The so-called four masters of the Wu area, namely Shen Zhou, Wen Zhengming, Tang Yin, and Qiu Ying, were all believers in Daoism. Their landscape works often contain scenes that were already popular in Yuan paintings, such as simple houses made of wood and thatch in the setting of mountains and waters, and relaxed intellectuals reading books or playing board games. Visualized in those images are harmony between nature and humans, as well as the senses of originality, simplicity, and vacantness, all of which are genuine Daoist ideas.

During the last dynasty in imperial China, the Qing (1644–1912), Daoism continued its dominant status in Chinese art. Art historians have found that even the four most famous Buddhist artists called "four monks of the Qing" were indeed practitioners of Daoist-style art. One of them, Shi Tao, left behind an important theoretical book about traditional Chinese painting. In the book he made numerous references to Daoist classics and interpreted Daoist ideology as the foundation of landscape painting.

To conclude this extremely condensed essay on the historical relations between Daoism and traditional Chinese art, we can say that Daoism as both a religion and a philosophy has had an unmatched impact on the development of Chinese art, and painting in particular. For more than two thousand years, Chinese artists found Daoism the best source of imagination and inspiration. Through their artwork, they expressed Daoist values. In short, it was Daoism that made Chinese art Chinese. ☯

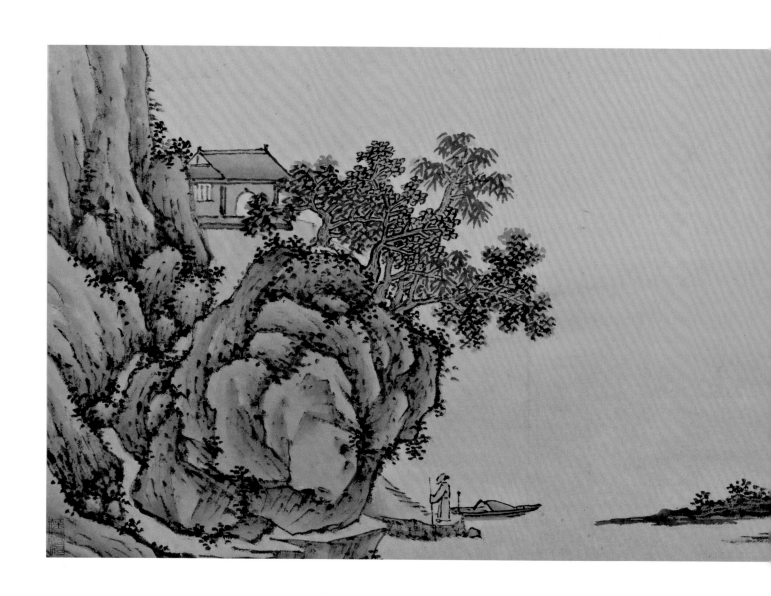

SHEN ZHOU
Album of Twelve Landscape Paintings
China, ca. 1500
Ink and color on paper
12¾ x 23 in.
The Mary M. Tanenbaum '36 Collection
Courtesy the Iris & B. Gerald Cantor Center
for Visual Arts at Stanford University

The Views

August 19, 1975

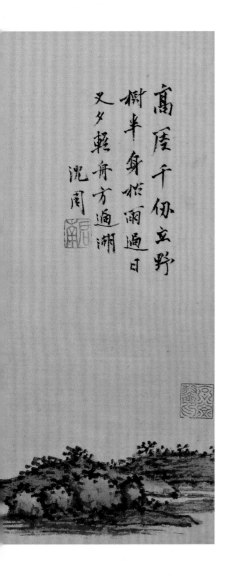

Chinese artists and scholars have long differentiated between the "near view" and the "far view." I am often reminded of this difference, as I live my life absorbed in the minutiae of my own small garden, my little pool, the play of light and shade upon my flowers. All of this constitutes, in reality, my "near view" for none of it is farther away from me than several feet. And it is mine; it is personal; I can easily identify with it. And because it is, as I, small in size, I can cope with it. My garden is also my responsibility—to weed, to plant, to clean—as much as it is my privilege to enjoy. I am of necessity intimately engaged with my garden, or my "near view."

It seems to me that the "far view," on the other hand—that to which we are exposed on our sorties to the open sea, to the grandeur of great mountains—is a little bit detached, a little bit inconceivable, a little bit formidable perhaps even by the very nature of its stunning presentation.

The two polarities of the "near view" and the "far view" are fundamental to a comprehension of Chinese art, and have indeed existed side-by-side throughout the history of Chinese art. I suspect that there is no one equipped to deliver a valid a priori judgment of the superiority of the one against the other. It devolves merely into a matter of personal taste.

After the faltering first steps of Chinese landscape painting, toward the end of the T'ang dynasty (A.D. 618–907), when the landscape first appeared as an alternative to figure painting, came the stunning majestic concepts of Northern Sung (960–1127), with their utilizations of the "far view" (or *kao yuan*).

The concept of the Northern Sung (including such masters as Li Ch'eng and Fan K'uan) was to project the philosophy of "man and nature," with man seen as no more than a tiny dot against the towering crescendo of mountain peaks—almost obscured by cliffs and towering trees, and barely visible in valley chasms. These landscape paintings of the Northern Sung give us indeed the "far view," where man finally finds his place, pigeon-holed against the gigantic gorges of the Yangtze.

The "near view" (or *p'ing yuan*), on the other hand, came about a little later, in the Southern Sung (1127–1279), partly as a result of a gentler structure in a new art center in the south. Lakes and hills replaced the river-mountain complex; a milder southern climate replaced the fierce extremities of the north; and in a newly discovered art form (as practiced by Ma Yuan and Hsia Kuei), individual gardens took the place of cosmic views.

I think, as I try to relate to the far view and the near view, that I am beholden to the near view, involved with it, conditioned by it, oriented to it, and that it is my view. It is with a matter of passion that I celebrate my near view. And it is mine—to nurture, to cultivate, and to improve.

I wonder if there is not, in the spiritual realm, a parallel to the near view, with its immediacy and its pleasure? Am I not of necessity more involved with that and those around me? And need I not water my own garden more assiduously than that of distant cousins or the Alps?

And should I not remind myself that, although I can sometimes see the distant mountain and acknowledge the far view, that it may be the view right here at home, the near view, which is in truth the pot of gold at the foot of my rainbow?

THE NEAR VIEW

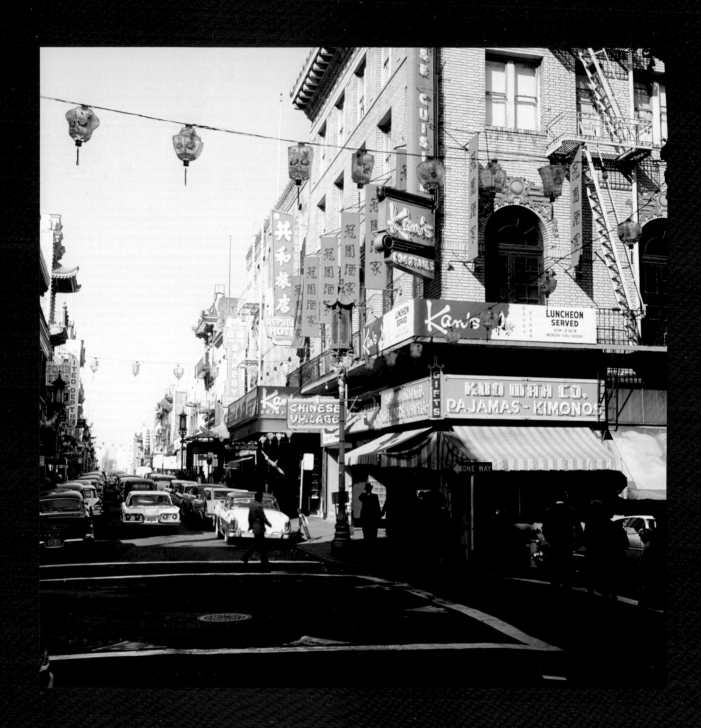

My Chinese San Francisco

It was Chiang Yee, the eminent author-artist of a score of "Silent Traveller" books, who said, "No one can comprehend Chinese landscape painting without knowing the city of San Francisco."

I think that what Yee referred to was the extraordinary similarity between the bay of San Francisco—its islands, fog, interplay of land and sea—and Chinese landscape painting.

Native of this fog-borne, sun-kissed city, I was born in an atmosphere more Chinese than China. In my travels to the Orient, I have yet to find a city—with the possible exception of Hangchou—so arresting in its water-land configurations as is my San Francisco.

The San Francisco that I grew up in, more than fifty years ago, was the same superb hill town that it is today, but there was much that was different. Those were the days before airplanes, bridges, high-rise buildings, television, and computers. They were also the days before inflation—when twenty-five cents would buy a Scotch at the Fairmont and when one could dance all night for a buck at the Mark.

My parents, a complementary pair, took me by the hand along the avenue of their own enthusiasms, which was to eventuate much later in a keen interest in Chinese thought and art.

My father, a lawyer, was a lover of the sea, and I well remember as a child walking with him around Lands End, that unique spit of land between the Presidio and the beach which gives upon the open ocean. Trailing at the rear, and hurrying to keep up with my daddy, I noticed that my inhalations and exhalations seemed to match the thunderous incoming and outgoings of the sea. (It was years later that I was to come upon the Chinese verbalization of this, of man's identity with nature, in the writings of Lao-tzu, Confucius, and the Buddha.)

Sometimes my dad and I used to poke around the Embarcadero. We would climb the planks piled around the piers to have a better view of the great Japanese liners nestled in their ports. Every ship was named "maru," and their names made an instant imprint upon my childhood mind.

I was fascinated. It was early exposure to a foreign culture. And music it was to me, long before I knew of music. "Hakone maru . . . hakone maru . . . hakone maru," I would repeat with endless satisfaction to myself, as later on, in school, I would silently repeat favorite poetic couplets and, even today, relish the repetitive thematic motifs of Mozart.

At the same time that my dad was bringing me to the ocean, my mother was bringing me to Chinatown, which I think lay the groundwork for my enthusiasm for the arts of China. We lived on Powell Street, up beyond its crest, at the corner of Sacramento Street, and frequently would walk downtown by way of Chinatown.

To be in Chinatown seemed to me like traveling at home. I loved it. Sights and sounds and smells were unusual and exotic. Buildings had upward flaring rooftops and were colorful, with a predominance of red. Signs were black and white and were undecipherable but glamorous. Little children, about my size, wore pigtails down their backs. Shop windows proffered extraordinary wares that seemed like radiant toys.

A special shop that we used to frequent on Grant Avenue was called Suey Chong, and the proprietor, Yiu Tung, was a silk and curio importer. His walls were lined with bolts of extraordinarily colorful silks in every hue. Mom and I would select silks there for me to wear at home—one color for the jacket, another for the pants. Then we would select, from a vast selection, a pair of harmonizing and embroidered Chinese slippers.

Opposite: CHARLES E. ROTKIN, **Chinatown**, San Francisco, California, USA. Copyright © Charles E. Rotkin/Corbis

Above: **Grand Opening of the Golden Gate Bridge**, Pedestrians walk across the Golden Gate Bridge on May 27, 1937, in San Francisco. Copyright © San Francisco Chronicle/San Francisco Chronicle/Corbis

Assigned to Adventure, Irene Kuhn
Publisher: J. B. Lippincott Company,
1938

As I look back now upon those early family days, it seems to me that there was an extraordinary closeness, not only among the three of us, but also among a vastly extended family. My mother's sister and two brothers, childless, took keen interest in me and contributed to a welcome sense of childhood security. And their friends, many of whom were also childless, became my "aunts" and "uncles," so that I grew up in a sense of comfortable illusion that my contacts spanned the globe.

One of my favorite ventures in those days was the ferryboat. As I remember, at that time in San Francisco, it was our only access to the north and east across the bay, although one could, of course, drive or take the train south to the peninsula and beyond.

We would use the ferryboat for a day's outing at the beach in Alameda, and to get to the train in Oakland to visit my auntie in Sacramento. We would use it to go to Sausalito, where I spent leisurely contented summers as a child, at the original Alta Mira, which was run by an old friend of my mother's, a romantic looking Elsa with a crown of gold curls.

When it came time for me to enter school, we were living on Sacramento Street just short of Arguello Boulevard, and my parents enrolled me in the neighboring Madison School, then located on Clay Street. I immediately liked school, perhaps because I was an only child.

One of my special joys about going to school was the school store, where for a penny I could have my pick of

what seemed like a million goodies. My favorite was the gigantic licorice whip, which tasted heavenly.

Moving on to high school, I went to Girls' High, then situated on Geary Street at Scott. My favorite teacher there was Evelyn Armer of the English Department. I had always liked writing and came to like it even more under her no-nonsense, disciplined instruction. Evelyn Armer and I enjoyed each other, and sometimes we would walk home together after school. I remember years later when, on the occasion of my marriage, she wrote a letter to me, urging me to make something of my life that my husband and I could both admire.

It was around this time that we moved to Jackson Street, near Spruce, where in short order I had a friend, Frances, living on the corner. Little boy-girl parties were starting then, and I well recall one dinner at her home where I received my first corsage, of freshest flowers!

A San Francisco home where I had among the best times of my youth was a salon, to which I had access as a good friend of the daughter. The hosts frequently entertained visiting artists, writers, and celebrities at parties at which the beloved art patron Albert "Mickey" Bender was a regular. Walls at their Washington Street home were lined with Japanese prints, including the *Fish* of Hiroshige.

Down the hill from Jackson Street, just into the Presidio, there was (and is) a playground, the Julius Kahn. There were several tennis courts there, and I often would "take winners." Sometimes I would sit on the bench alongside the court for seeming hours, waiting to play the winner of a game. In short order, I became addicted to the game of tennis. I entered a city championship for girls sixteen and under, and I went all over the city playgrounds to play my matches, including Golden Gate Park. Finally, I was the winner.

To celebrate my championship, my family treated me to membership in the California Tennis Club (affectionately known as the "Cal Club") at Scott and Bush Streets. It became my home-away-from-home.

Those were the days when all top lady players played the Cal Club. And for me it was a thrill to simply look at Helen Wills Moody. I recall asking her why she took hot tea after the game and she answered that she found it more refreshing than cold drinks. I have been reminded of this comment many times in subsequent years—in the tea drinking countries of India, Japan, and China.

My addiction, tennis, of course went with me to Stanford University, where I would play at six in the morning prior to my eight o'clock classes.

The Stanford class of '36, my class, was the last of the famous "five hundred," or overall limit on women in attendance at the university. Today, with the enormous expansion the school has undergone, there are more than five hundred women in every class!

I lived in the brand new Lagunita Hall, then the women's dorm opposite the women's gym and tennis courts. I had a lovely corner room in front, with two windows.

The "lib" (or library), now converted with elegant accoutrements into a center for special collections and rare books, was then perfectly plain and utilitarian, but adequate. And, we went around the campus on foot, antedating the contemporary cult of the bike.

While still a student, I felt especially close to Lake Lagunita and walked around it for serenity and relaxation before and after final examinations. I was later to learn that Lao-tzu urged man to return to nature for serenity and peace.

My graduation from Stanford brought an acceleration of my lifestyle. It was as though I moved on from andante to allegro.

I drove over the Golden Gate Bridge on opening day with George, a fellow with the *Cal Bulletin* whom I used to date. I remember it as an orderly, inspirational, and perfectly beautiful day. The day was imbued with novelty, excitement, and a wonderful sense of prescience that this dazzling Chinese-red bridge spoke of new wonders for our world.

Here were the familiar tawny hillsides of Marin: elevated as we were, we saw them differently. But the wonders of the day were not merely geographical and visual; they were also about time. In what seemed like a minute, we had crossed the bay.

The Golden Gate Bridge. What a wonderful name for this stunning new reminder of our closeness to the Orient.

After graduating from Stanford University, I worked with Joseph Henry Jackson, who was reputed to be the only Western bookman with a national reputation, as book reviewer for the *San Francisco Chronicle*. I would go down to his office every Thursday and select a book in nonfiction or the arts to review for the Sunday paper.

Already, my predisposition for the Orient began to surface. One day a title on a spine seduced me from a shelf: *Assigned to Adventure*. I thumbed through the pages and found it to be a newspaperwoman's story about her experiences in China. The author, Irene Corbally Kuhn, was to appear years later in my New York life, and we were to enjoy many lunches together in New York's Chinatown.

About this same time, in 1937, on a visit to New York with my mother, a friend introduced me to Charles. On only our sixth date, we were married. The wedding took place in my mother's Powell Street apartment in San Francisco. Charles and I honeymooned at Del Monte and set up housekeeping in New York.

It was Mickey Bender who, at our wedding reception, brought me as a present my very first piece of Chinese art. Today it sits prominently beside my phone as a paperweight. It is a handsome buckle with a centered slab of rose quartz, flanked with jade and set in gold.

I found New York glamorous, colorful, interesting, and even dynamic. But never homey. I never really left San Francisco: the hill-and-water ambience of it, the strong Chinese flavor of it, the temperate climate of it, the old friendships of it.

And, now, it is mine again, this wonderful hometown, which I have never really left. I have inherited an apartment on Green Street, on top of Russian Hill, where I happily spend a good part of every year. A steady stream of friends, from in and out of town, comes to gasp at the view and to enjoy the visibility of the bay and of the city.

One New York friend said to me there recently, with a smile, "You are *the connection*," suggesting that it is in my San Francisco apartment that Easterners experience the West. Connection or not, it is with gratitude that I return to San Francisco, and, after more than half a century, am again at home in this unique city.

ARNOLD GENTHE, **Opium Smoker,** Chinatown, San Francisco, ca. 1905, Gelatin silver print
Courtesy the J. Paul Getty Museum's Open Content Program

当我"什么也不做"的时候，我在做什么？
《基督教科学箴言报》 1975 年 8 月 19 日

当我"什么也不做"的时候，我在做什么？

我也许正看着窗外，观察自然的各种情绪变化。艳阳天…雨天…大雾的早晨…起风的下午…静谧的傍晚。我还想我自己的情绪如何变化，就跟自然的情绪一样，甚至受它们的影响。

从我那扇通向世界的窗口，我还可以欣赏季节的更换：春天，橡树枝上刚刚长出嫩叶；夏天，叶子成大成形；秋天，它变成金黄色，变干燥，然后落下；冬天，被一层薄冰覆盖的光秃秃的树枝在阳光的照射下闪耀。

我思索自己的生命是如何的相似，不仅与自然的情绪变化一样变化，也与一年四季的变化一样轮替。生命也有自己的情绪，也有季节的更换。

我想我对自己具有这种"无为"的倾向是如何地感激。在我看来，这种"无为"的态度非常有益。它使得我更欣赏美妙的室外世界，就算我只是通过一扇窗口看着它。它帮助我更好地把自己理解成自然的一部分。它还强化我对自己的身份和位置的意识。

进一步说，它让我具有更深刻的观察力，给我真正的快乐。它还给予我一个经验的宝屋，我今后不仅可以用智慧还可以用情感去参考它。

这种"无为"的概念——或者，按原作者的说法也就是"坚持宁静"——是 5 世纪中国哲学家老子的思想的基础。

在一个基本上被发狂的生活方式控制的世界，让我们有勇气保持寂静。这种生活看上去什么也不"做"，但是可以成就一切。

What Do I Do When I Am Doing Nothing

August 19, 1975

What do I do when I am "doing nothing"?

I may be looking out of a window observing the many moods of nature. A sunny day . . . a rainy day . . . a foggy morning . . . a windy afternoon . . . a still and quiet evening. And I think of how my moods change, as do the moods of nature, and even sometimes seem to be induced by them.

From my window on the world, I also can enjoy the sequence of the seasons: spring, when the earliest leaf bud takes shape upon an oak tree; summer, when the leaf matures to fullest size; autumn, when it turns to orange-russet, dries, and falls away; and winter, when overcoatings of thin ice upon bare branches dazzle in the sunlight.

I think of how much my own life has in common, not only with the daily moods of nature, but also with the sequence of the seasons of the year. It, too, has its moods, and it, too, has its sequence of the seasons.

I think of how grateful I am to have this tendency of "doing nothing," as it seems to me that this sort of "doing nothing" can be very richly rewarding. It helps me better to appreciate the wonderful out-of-doors, even though I am looking at it only through a window. It helps me better to understand myself as part of nature. And it gives me a reassuring sense of identity and place.

Further, it leads me to sharpened observations. It affords me real delight. And it provides me with a treasure house of experience, to which I can later refer with affection if not with wisdom.

The concept of "doing nothing"— or, as he calls it, "holding fast to quietness"—is basic to the thinking of Lao-tzu, fifth-century B.C. philosopher of China.

In a world much motivated by a frenetic lifestyle, let us have the courage to cast our nets with the quietness that seems to "do" nothing yet achieves everything.

"What Do I Do When I Am Doing Nothing" translated into Chinese

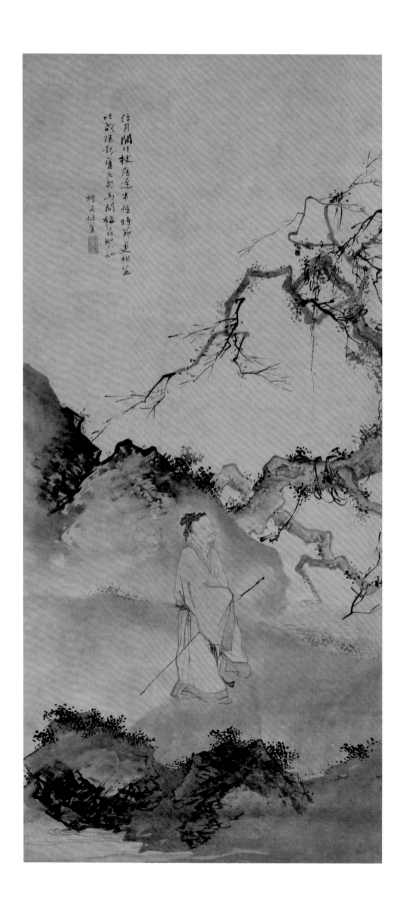

陰月開川杖履庭來幽時節還相思
吟歌瘦影萬丘島為問梅花幾知

增而林畫

DU JIN
**_The Poet Lin Bu Wandering
in the Moonlight_**
China, late 15th century
Hanging scroll; ink and color
on paper
61½ x 28½ in.
The Cleveland Museum of Art,
John L. Severance Fund (1954.582)
Photography © the Cleveland
Museum of Art

A Good Day

June 14, 1982

"Have a good day" has become a most common comment, in vast sections of the Western world.

One hears it from people in one's home, from tradespeople, cabdrivers, telephone operators, and friends. One hears it to such an extent that I start to wonder, "What constitutes a 'good day'?" Then, I wonder, "What can I do to ensure a 'good day' for myself?" I think that a "good day" may be relative, and that what is a good day for one person may be an abomination to another. For example, I am married to an intellectual, a scholar of infinite energies. To him, a good day is the exercise of the intellect, whereas I suspect that for me, a good day is apt to be centered in the country, where the good air, as well as the peace and quiet, is salubrious. I am quite aware that this attitude is not universal, and that there are those who prefer the clang of subway trains to the chirping of birds.

For me, a good day, in a country setting, is apt to involve a return to Chinese philosophic verities, which extol a unity of man with nature. I am apt, on a good day, to observe the graceful movement of a bamboo bush . . . the staccato conformation of a pine . . . the luxuriant unfolding of the whitest peony . . . the inexorable strength of hardest rock. But, the observation is not an end in itself on a good day. The observation carries in its wake an eternal reminder of symbolisms rooted deep in Chinese thought. As I observe the bamboo waving with a gentle to-and-fro in the breeze, I think of the ancient heritage of bamboo symbolism; strength to tarry with the winds of life, but not to break. And, in my observation of the pine comes another deep awareness, again that of strength, but this time because the pine weathers the coldest winter without a loss of leaves.

Now this philosophical contingency to my observation is not merely in the abstract. It stimulates probing and inquiry within me. It is finally and profoundly introspective. Am I strong? Am I waving and not breaking, as the bamboo suggests? Am I strong? Am I weathering my winter without a loss of leaves or cheery demeanor, as the pine suggests?

A good day, for me, need not be a sunny day. It can be foggy, overcast, or cool. It can be snowy, drizzly, or rainy. I try to emulate the Chinese naturalists, or hermits, who find beauty in the day regardless of climate.

A good day, then, for me, becomes a day of sublime inspiration—a day wherein I have the opportunity to bring my own attitudes in line with ancient Chinese wisdom, which is as viable today, in all its art forms, as it was three thousand years ago.

WU BING
Bamboo and Insects
China, late 12th century
Album leaf; ink on silk
9.7 x 10½in.
The Cleveland Museum of Art, Gift of
Mrs. A. Dean Perry (1964.154)
Photography © the Cleveland Museum of Art

Bewitched by Bamboo

October 15, 1974

I often go out into my garden and trudge down to sit on a big flat rock, which extends almost into a little garden pool.

Over to my left, a bamboo bush juts an unruly branch almost into the water. Every breeze, ever so slight, bends the branch of bamboo; but when the breezes pass and tranquility returns, the bamboo branch returns to its original upright position.

If I have some problem on my mind, I observe these vagaries of the bamboo with a special interest. I think back to an ancient and much-quoted Chinese adage that says, "Be like the bamboo, which bends in the breeze and does not break."

Am I not, myself, just like this bamboo? Jolted, unseated, by a sudden storm of life? And can I not be, again like the bamboo, reordered in my course?

And, suddenly, as I ponder the bamboo, while seeing myself in identification with it, the vexing problem seems to disappear; my andante mood turns to allegretto, and once more my senses sing as with the birds.

Long known to Chinese thought as one of the major instruments whereby man attunes himself to nature, the bamboo figures prominently in the annals of Chinese art. It has inspired many paintings, which can be substitutes for the plant itself in our contemplations.

From ancient times, the bamboo has also been one of the "Four Gentlemen"—along with the plum blossom, the orchid, and the chrysanthemum. All four are thought to be exemplary in their virtuousness, and the bamboo appears to possess a very host of virtues. Not only does it bend and yield. It also has a strong outer skin, which stands for strength, while its hollow body suggests openness to truth and reason.

Number one man among bamboo painters, in the history of Chinese art, is Wen T'ung (1018–1079), of the Sung dynasty. Wen exerted profound influence, not only on artists who came after him, but also on such outstanding contemporaries as the artist-statesman Su Tung-p'o, who ordered one of Wen's bamboo paintings engraved on stone for lasting inspiration. Wen's influence also guides the eminent Chinese-American artist of today, C. C. Wang, who finds in the delicate realism of Wen T'ung a model for his own bamboo paintings.

I well remember the day I first became aware of bamboo—both in nature and in Chinese art. "There is something magical about these bamboos," I felt. "They seem to be almost like people."

I was yet to learn that bamboo, in its extraordinary versatility, not only had a range through which it seemed to identify with people but, more importantly, the converse: that people can identify with bamboo, and through it find a wonderful lesson which can serve them well in their daily lives—the lesson of resiliency.

枯木竹石曹雲西遠之
稠庵

QI BASHI, HUANG BINHONG, AND FRIENDS
Presentation Album 1938–1940
China
Ink and color on paper
12 x 7½ x 1¾ in. (album), 12 x 13⅞ in. (each painting)
The Mary M. Tanenbaum '36 Collection
Courtesy the Iris & B. Gerald Cantor Center for
Visual Arts at Stanford University

The Tree in Winter

January 19, 1977

I am often overwhelmed by the beauty of the winter, and I think of the way it not only rivals, but also surpasses, the beauty of the spring.

Colors are clearer, and forms are more distinct. Water seems a more penetrating blue. Trees, their narrow trunks unrelieved, adorn the landscape like elegant giraffes.

There is no end to the physical beauty of the winter tree. White birches play hide-and-seek with sunlight as they fling their upper branches against an azure sky. Oaks spread chubby stalwart fingers wide, like open fans. Dogwoods pirouette like ballerinas. And pines muster strength in the fingers of their narrow needles to play host to cotton balls of snow.

But the delights of the eye are only a beginning as I contemplate the wonders of the winter tree. Am I being—in my relationship to others, and to life itself—ample like the oak? Delightful like the dogwood? Hospitable like the pine?

Can I detect, in my own living pattern, a parallel resplendence in maturity? Do I see unsurpassed beauty in the winter tree? Is there greater purpose in my planning, as I divest myself of the "leaves" of accommodation to my spring and to my summer? And, finally, is my own statement more linear, structural, abstract, and effective— as is that of the winter tree?

The Chinese landscape artists have long identified themselves with winter trees in their maturity. Wen Cheng-ming of Ming times (1368–1644) is known to have featured self-portraits of himself in the shape of gnarled and grotesque, and yet superbly compelling, pines.

In Wintry Forests, a recent exhibition of Chinese landscape painting at the China Institute in New York, Wen Cheng-ming was joined by Hsiang Sheng-mo (1597–1658) and Tao-chi (1641–1720), among others, in a broadly based panoramic view of the popularity which this concept has enjoyed among outstanding Chinese artists.

Nor is this attitude, of aesthetic-philosophical identification with the winter tree—so much enjoyed in the long history of Chinese art—an attitude only belonging to the past. In modern times, the contemporary Chinese American artist, Chen Chi, terminates a "China Sketchbook" with *An Old Tree from My Hometown, Wusih*. Are we not to deduce that the "old tree" is, in fact, Chen Chi?

It seems the tree has long served the Chinese artist as one of the techniques whereby he can best affiliate himself to nature. The tree seems not only to go through similar periods to man in its life cycle, but also to acquire the same wrinkles and warts in its maturity— and yet to compensate for them with a drama and effectiveness unknown in earlier stages.

As we roll out the handscrolls of our lives, and as we reconstruct in our mind's eye the trees we have observed, can we not expect for our own selves the ultimate—that is, that winter will give us, as it gives trees, the greatest glory?

The Stone of Heaven

February 19, 1975

The Chinese emperors used to give jade scepters as rewards to their outstanding artists, writers, scientists, and explorers. Today these same scepters can serve to bring us, all of us, close to nature.

One wintry, blustery day, some years ago, while rummaging in a secondhand art shop, I happened to come across one of these jade scepters. Its whiteness was as pure as the freshly fallen snow. Almost trembling with excitement, I took the long shaft in my hand to study the carving on the top. The carving was incisive, clean; the design, irresistible on this snowy day, was of a figure relaxing amid a fragrant stand of pines.

"What a lovely place to be!" I thought, as for a moment I identified with the little figure and fancied myself in more balmy climes and places. Unable to part from this wondrous new illusion, I paid the modest price the salesman wanted for the scepter; and with a joyous sense of keen thanksgiving, I took my scepter home.

From time to time—whenever I want to enjoy the sensation of being in the country—I pick up my scepter, and I study the fine carving on its head. I think back to the philosopher Lao-tzu with his emphasis on seeing oneself as "part of nature." And I think back to Confucius, who set a high moral tone for jade when he called it "the stone of heaven."

And then I think of the various symbolisms in the little landscape. I think of the pines—and how they stand for strength and for longevity because they weather the cold cruel winter and never lose their leaves.

Most of the jades that we see today come from the reigns of the Ch'ing-dynasty emperors K'ang Hsi (1662–1722) and Ch'ien Lung (1736–1795). These emperors loved jade so much that they supported workshops for the carving of it within the confines of their palaces. In these workshops, the craftsmen would receive the boulders brought in from hills and streams, excavate the dazzling sections of green and white, and carve them with magnificent designs. The emperors were not just detached enthusiasts of jade; they took a lively part in its production. The emperor Ch'ien Lung himself often wrote poems to be transcribed onto the actual surface of the jades.

Once the property of emperors, jade today is available to us all. We can enjoy it in museums, and we can have it in our homes. And not only in our homes, we can have it in our heads and in our hearts, as our own direct avenues to lovelier places.

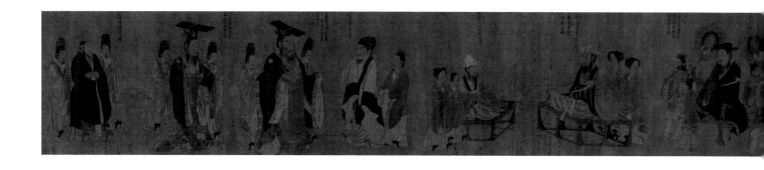

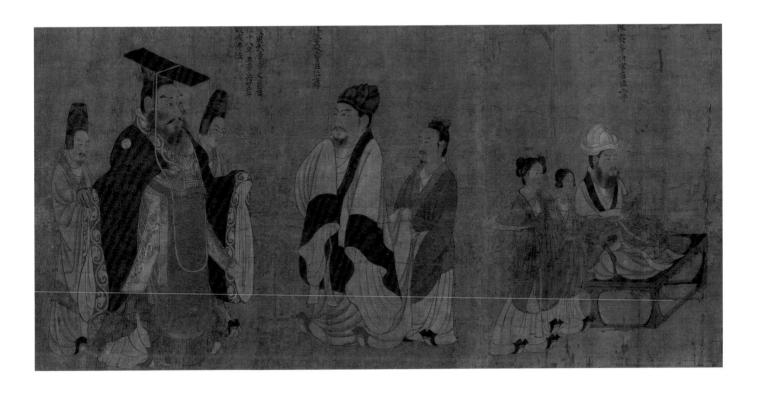

ATTRIBUTED TO YAN LIBEN
The Thirteen Emperors
China, Tang dynasty (618–907)
Ink and color on silk
20 ³/₁₆ x 209 ¹/₁₆ in.
Museum of Fine Arts, Boston,
Danman Waldo Ross Collection (31.643)

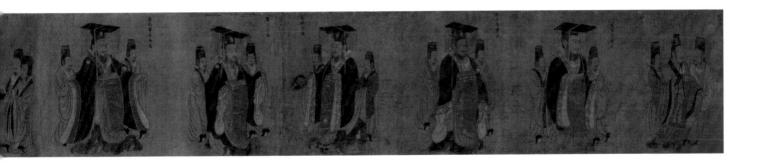

SHEN ZHOU
Album of Twelve Landscape Paintings
China, c. 1500
Ink and color on paper
12¾ x 23 in.
The Mary M. Tanenbaum '36 Collection
Courtesy the Iris & B. Gerald Cantor Center for
Visual Arts at Stanford University

The Longest Steps

October 5, 1976

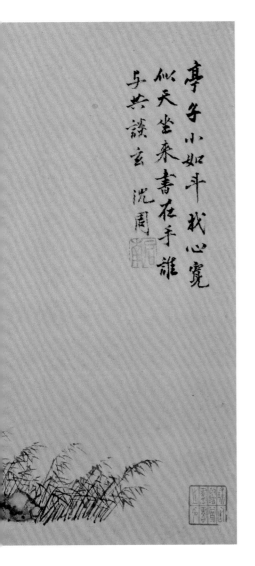

An unforgettable, and I find always timely, comment from the fifth-century B.C. Chinese philosopher Lao-tzu is one to the effect that "He who takes the longest steps does not walk the fastest."

Perhaps this quotation is of particular appeal to me because I am small. My steps are not very sturdy. And yet I like to feel, nonetheless, that I do get somewhere.

I think sometimes of the vast distances I have covered over the years on trips to remote, faraway places; and how little of it stayed with me, or now seems to have proved of lasting significance.

And I think, on the other hand, of the vast significance that appears to be entailed in activities that are really hardly any activities at all. Like looking out of a window. Or sitting on a rock. They require hardly any steps at all.

"The longest steps," it would seem to me, in the phraseology of Lao-tzu, refers to physical activity, to the covering of space, to the peripatetic activity of motion.

On the other hand, "the fastest walk" refers, rather, to a mental action . . . to a conquest or achievement . . . to a progress or progression, most frequently in regard to the orientation of the individual to the experience of life.

And so it would seem to me that the real achievement, that of comprehension of what life is all about, does in no way relate to grand tours or one-night stands around the world. It relates, in all probability, to a thoughtful frame of mind and a comfortable seat. It has nothing to do with covering space. It has more to do with an amiable receptivity to thought.

To walk the fastest, to achieve the most, then, has nothing to do with walking as an exercise. It is, rather, walking as a comprehension.

This sort of parable, which is so utterly Chinese and so utterly delightful, can best perhaps be fortified by the use of another and not too different parable. Elsewhere in his book, *Tao Te Ching*, Lao-tzu says, "Tao in the universe is like the southwest corner of the house." Does it not seem likely that what he means is that the house is the mind; and when the mind is filled with comprehension of basic rules of being, that the awareness is "southwest"— that is, filled with sun and light?

Lao-tzu himself is often pictured in Chinese painting in contemplative mood, sometimes astride a donkey, lazing and lazy. He is not running around, covering a great deal of space. He sits there, frequently astride his donkey, and he muses and he thinks; and his musings and his thought have inspired not only his time but also generations, centuries, millennia.

Lao-tzu has given me the inspirational awareness that, taking no steps at all, I can scale the heights of comprehension. I can cover ground with no movement. I can find, right here at home, philosophy and understanding, as well as more surpassing vistas than those for which others circumnavigate the globe.

PU JIN
Discussing the *Plum Blossom Painting* (detail)
China, ca. 1946
Handscroll; ink, paper, and silk 9⅞ x 25½ in.
Collection of Ann Tanenbaum
Photo: Jeff Wells / CU Art Museum

Nature's Characters

July 7, 1980

Rocks, to the Chinese, are yang motifs. Strong and assertive, they thrust upward from the earth in positive posture.

I look around my garden and think about the different personalities of various rocks, as I observe them thrusting upward.

There is the rock I call "the barrister." About two feet high, and narrowly conical in shape, its upper part and rear are magnets for the falling snow in wintertime, so that it takes on a whitened wig and looks for all the world like an English judge, as I have observed them in the courtrooms. Because this rock (the barrister) is totally vertical in its outline, it is, in its philosophic implications, completely yang—completely strong and declarative.

On the other hand, there is the rock I call "the philosopher's seat." It is down by the pool; I often like to sit on it and think over the meanings of the garden elements. The philosopher's seat is flat on top to make for easy sitting. And although it thrusts upward from the earth in ample good proportions, the flatness of the top seems to introduce a quality of yin, or easy plateau nature.

Other rock structures in the garden, as I look around them, seem to bear out the duality suggested by the barrister and the philosopher's seat. They are either of unrelieved and active verticality or they are flattened on the top, suggesting yin admixture.

I sometimes think how rocks are little mountains, and how, as a leitmotif, they echo the strong statement of the mountains. And in the rocks, as in the mountains, we come across the duality of both sheer loft and tabletop.

Sometimes, in connection with the rocks, I think of the great contemporary Chinese-American artist, C. C. Wang, whose mammoth collection of rocks is on permanent display in glass cases in his New York home. One time I asked him what attracted him so much to the rocks, and he answered, "They are nature's sculpture." I think his reference was to the yin and yang motifs, which characterize all of nature.

Rocks have also been very important, historically, in China. I often think of the importance of the rock in Chinese Buddhist sculpture, and of how, from the fifth century, the great temples of Yongkang and Lungmen were carved out of rock formations. Rocks came to be the medium through which historic Chinese sculptors conveyed their philosophic and religious tenets.

Are not rocks, as seen from the Chinese point of view, another instance of our involvement with all nature? Do "the barristers" not parallel our drives and aspirations, and the "philosopher's seats," our periods of comparative quiet and serenity?

The Symbol of Summer

July 27, 1977

The butterfly, to the Chinese, is a symbol of the summer.

Looking around my garden one recent summer day, I suddenly saw a host of butterflies, all white, flitting about my all-white flower beds and pools. The gossamer white lightness of the butterflies seemed to pick up the all-white planting in the garden and transform it into another world, the world of motion.

Exploring the lifestyle of the butterfly, I felt no sense of guilt at my invasion of his privacy, for my attention seemed to disturb him not at all. He was almost, like a ballet dancer, grateful for my attention, and he preened and pirouetted for it.

I moved over to study him at close range. How light he seemed! Like tissue paper or thinnest parchment, his little wings extended full, with two small black dots inside of each, when he alighted on a flower. How indistinguishable he was, as he came to rest upon the pure white petals of impatiens. And how almost invisible he was, as he contracted his two wings into razor thinness, to explore the stamen of the flower with his wire-thin antennae.

How extraordinary is this butterfly, I thought, as I observed his artfulness. How unique he is, with the purity of his color and the lightness of his form. And how, at the same time, he manages to blend, almost indistinguishably, with his surroundings, in perfect harmony.

I thought about a friend of mine, a physician who used to reminisce about this wonderful ability to naturalize in nature, as he had observed it with the elephants on safari in East Africa. And I thought, with a sense of joy and comfort, that I need not go to East Africa to observe the naturalizing proclivities in nature, that I can enjoy them right here in my backyard.

The airborne gyrations of the butterfly indeed bear out its being called a symbol of the summer. It flits about haphazardly, with a little bit of irresponsibility, a little bit of lacking-in-direction. It picks

up partners along the way and careens quite closely in a sudden pas de deux; but, like a summer romance, the partnership lasts only for a moment, and then the butterflies part company again, never again to seek out each other.

Sometimes I think of the butterflies as snowflakes of the summer. They have the same purity of color, the same chiffon thinness, and the same ability to spellbind—to attract and hold attention.

Butterflies have long intrigued the Chinese mind. One of the most often quoted stories from venerable Chinese classics concerns Chuang Tzu, chief historical spokesman for Taoism and its founder Lao-tzu. Chuang Tzu, writing in the fourth and third centuries B.C., was intrigued with the supposition that perhaps he was in reality a butterfly, and that he was only daydreaming that he was a man.

The artist Ch'ien Hsuan (1235–1290) has painted an exquisite hand-scroll, *Early Autumn*, reproduced here, and it shows how unobtrusively the butterfly comes to naturalize in nature.

May I not, myself, learn a profound lesson from the apparent lightness of the butterfly? May I not learn to see myself, like the butterfly, as naturalized, as enveloped, within the grand design of nature?

QIAN XUAN
Early Autumn
China, 1235–1305
Ink and colors on paper
47¼ x 10½ in.
Detroit Institute of Arts, USAFounders Society purchase, General Membership Fund / Bridgeman Images

Enjoy in Solitude

August 29, 1978

My garden is the place where I most easily and most effectively insinuate myself into all of nature.

I often sit on a little outdoor porch, which overlooks the total area and gives me delicious access to thought-provoking visions in the garden.

Sometimes seasonal flowers are out in bloom, and they catch my eye. Early bloomers are the irises, of which my favorite is the small flat white Japanese, with its delicate yellow striation; and I think about how much it resembles the Chinese orchid, with its message of modesty. About the same time that the irises are out, the huge white peonies also are in flower, and as I look at them, I am reminded of their symbolism of luxury, which I now construe to be a nature-orientation. Autumn brings me the flowering of the chrysanthemums; and, as I look at them, I am reminded of how they represent the need for strength—they are the last flowers to be still blooming in the late fall garden.

But apart from flowers, much of my exploration of the garden focuses on evergreens. There are the bamboos, waving ever so gently in the wafting breezes, and perpetual reminders of resiliency, with their ability to bend and not to break with the storms of life. And then there are the pines that seem to say, "Look at me! I represent fortitude, because I go through the long cold winter and do not lose my leaves."

There are also a host of other items in the garden, besides the plants, which are at once delightful to look at and constant reminders of my participation in the world of nature. There is the water, with its dual message of strength and humility. There are the rocks, with their structural variations, from flat to tall. And there is the compositional geography of the garden, which rises upward from a low valley (or yin) to a high hill (or yang)—a timeless reminder of the lows and highs that characterize not only my life but also all of nature.

I feel that I very well understand the Ming-period artist Ch'iu Ying (1510–1551) and his *The Garden for Self-Enjoyment.* We are separated by four centuries, he and I, but we are of identical attitudes in the disportation of our time. He, too, sits in luxurious ease within the garden confines—his gazebo, not too different from my porch. He, too, meditates upon his pines, bamboos, and plants. And he, too, sees them as models and as philosophical motivations for his lifestyle, because their meanings are integral to the Chinese culture of which he is a part.

I quite agree with Ch'iu Ying that the garden is best enjoyed in solitude. It is in solitude that I can be relaxed and somehow dedicated . . . and that I can best focus on all of this and at the same time summon up a range of poetic and artistic and philosophical allusions.

Regardless of time and regardless of place, we can all find and take comfort in our garden—even if it is but a plant upon the windowsill that suddenly bursts, out of nothingness, into brilliant flower.

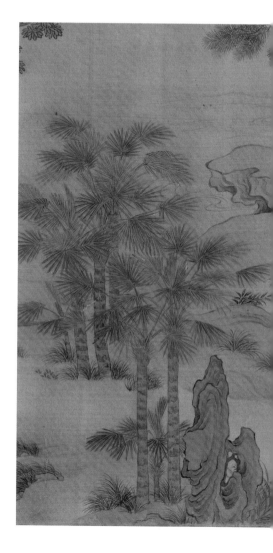

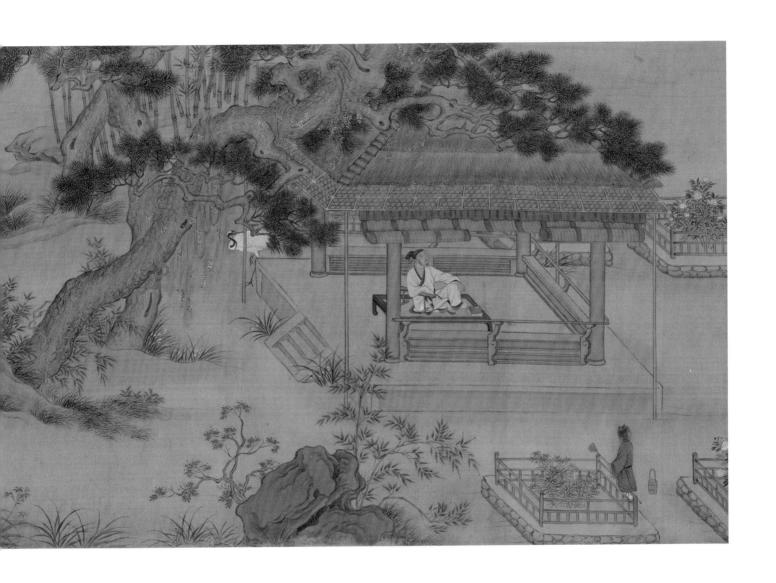

QIU YING
The Garden for Self-Enjoyment
China, 1515–1552
Handscroll; ink and slight color on silk
211 x 150 in.
The Cleveland Museum of Art, John L.
Severance Fund (1978.67)
Photography © the Cleveland Museum of Art

My Friend the Sun

August 7, 1978

The sun, bright and assertive, is the yang motif to the Chinese. Brilliant, strong and powerful, it radiates the world with light. It is in contrast to the mellow, gentle yin motif of the moon.

Destined to bring light and visibility to the earth, the sun makes its first appearance in its dawn of immense theatricality. I hurry to my bedroom window to observe its dramatic pyrotechnics.

Sometimes the pale gray-blue sky is shot with horizontal bands of mauvish gray—and underneath, a flow of distilled orange appears like a riverbed—as the great orb of the sun prepares to rise. The scene is so outrageous in its drama, so flamboyant in its colorfulness, that it suggests a setting for grand opera.

Swiftly comes the climax of the rising sun. Draining color from its setting, it shoots up, center stage. It is a lively vital rounded ball, in vibrant Chinese red—a color which is soon to disappear within moments of its rising.

It seems as though the color, formerly held within the sky, now reverts to earth, as a new day dawns. And sunlight makes its merry rounds of animation.

As I look around my garden in the daylight and see that it is charged into dazzling brilliance by the sun, I realize that this world of high excitement costs me nothing. There is no charge for my front-row seat, as I observe, in solitary splendor, the greatest theater of all time. There is no price I have to pay for this most priceless assemblage of performing arts: the ballet of the birds, the still life of the flowers, the musical nuances of the rustling leaves—all of which take on new life when jostled by the sunlight into lively prominence.

And I think of my indebtedness to the sun and to its energizing light. Not only does it sustain the fruits and vegetables, it also radiates my scope, so that I can see and enjoy, in brilliant light, a thousand wonders, in any place my eye may fall. In short, the sun fosters me physically, at the same time that it pampers me aesthetically.

I also think that, through its radiation, the sun gives me the opportunity to be never lonely, though alone. In permitting me to see and enjoy the bamboo, the pine, the water—with their symbolic characteristics of yielding, strength, and softness—the sunlight motivates my capability of feeling myself at one with all of nature. And how can I be lonely when alone, as long as I can share the spirit of all nature? Indeed, there can be no circumstance when I feel less lonely than when alone and in my garden.

Chinese thought has eternally held that the sun, or "great luminary," is the concrete essence of the masculine principle (yang) in nature, and the source of all brightness.

When we feel strong, powerful, brilliant, and bright, are we not sons of the sun? And do not our personal comptometers accommodate us to the bright, as well as the night?

A Paragon of Order

November 19, 1975

The life of the insect is dear to the heart of the Chinese.

Hundreds of poems and thousands of paintings have focused upon ants and bees and grasshoppers and dragonflies. Differing from Westerners, who are scornful of insects, the Chinese are compassionate toward all forms of life, however small.

On a hot day in summer, I occasionally see a dragonfly spinning circles in an area above the water in my garden pool. Occasionally, it lights upon a rock. It makes a buzzing little sound, and its diaphanous wings are vibrant in their bluish-purplish cast.

It makes me think back to a dragonfly my husband gave me, many years ago. Of jade, in dark imperial green, it captures the colors of tropical-sea depths in the sunlight. Its little head and its accoutrements of nose and mouth and eyes are meticulously carved. And in contrast to the small and dainty head are wings that seem to spread out almost to infinity.

I think how delectable is this dragonfly, since it is carved in jade. And I think of how the Chinese jade carvers were never whimsical about their work, but struggled always to project some philosophical idea.

What is the philosophy, or the symbolism, behind the insects? And what can it mean to me? Why have countless Chinese poets and countless Chinese artists chosen to immortalize insects in their arts? And why did a carver choose to do, long

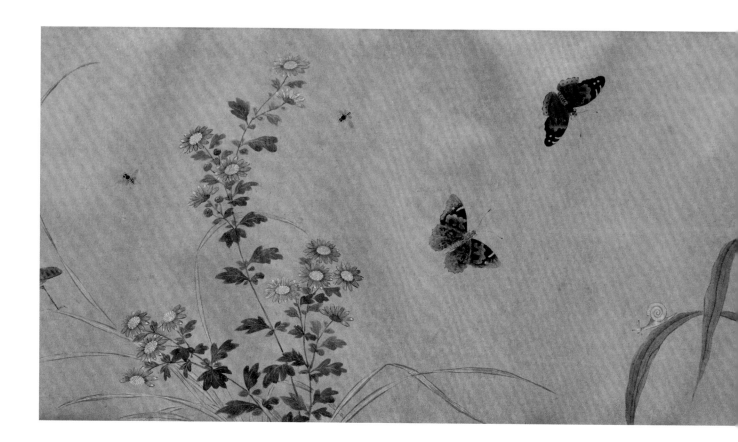

ago, a representation of a dragonfly in jade of all things, most revered and beloved of all the Chinese elements?

The Chinese are not merely compassionate about the insects, nor do they merely find them beautiful. To them insects are paragons of order. Their observations of the insects lead them to marvel at the order of their lifestyles, and to try to emulate it in the conduct of their own.

Insects have long inspired Chinese artists, and continue to do so today.

How "at home" the butterfly appears in its environment! How content, and how relaxed. And how it brings a new dimension of animation to the plant that harbors it.

Would it not, indeed, be a cause for joy in the world today if society paid attention to the example of the insect, and found inspiration in its orderly conduct, its nonviolence, its calm acceptance of itself.

UNIDENTIFIED ARTIST
Insects and Flowers
China, early 20th century
Handscroll on paper
314½ x 12 in.
The Cleveland Museum of Art,
Gift of the John Huntington Art
and Polytechnic Trust (1915.617)
Photography © the Cleveland
Museum of Art

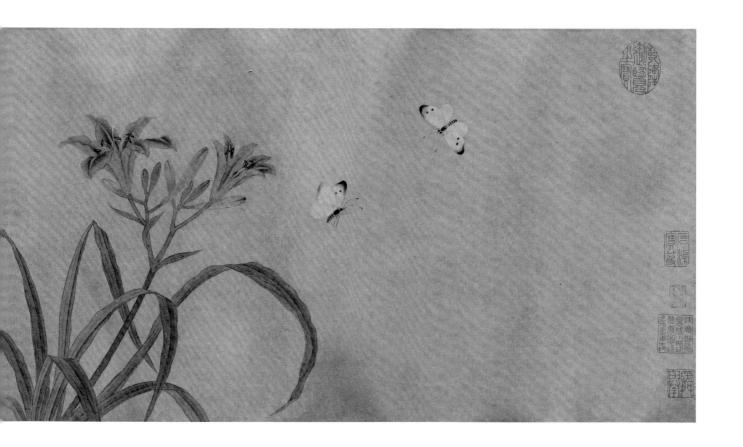

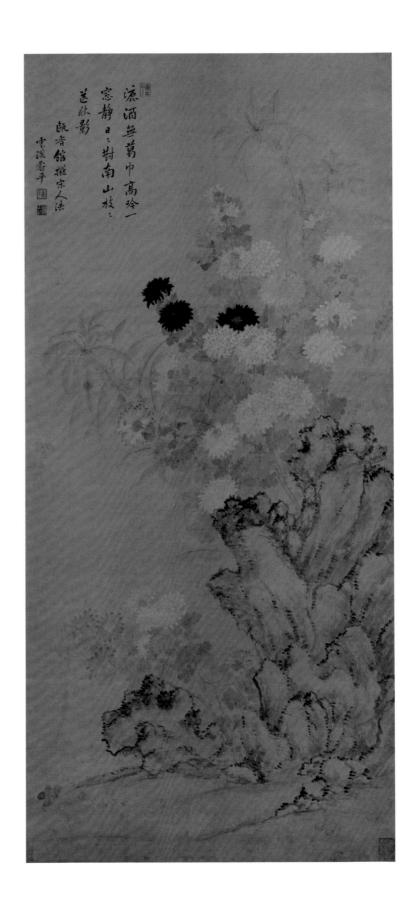

ATTRIBUTED TO YUN SHOUPING
Chrysanthemums
China, Qing dynasty (1644–1912)
Hanging scroll; ink and colors on paper
Image: 51 3/16 x 24 in.; mount: 118 1/2 x 32 7/8 in.
Princeton University Art Museum, Gift of
Dubois Schanck Morris, Class of 1893 (1947-47)
Image copyright © Princeton University Art
Museum / Art Resource, NY

Autumn's Flower

November 11, 1977

The chrysanthemum, to the Chinese, stands for longevity, because it is the last flower to be found still blooming in the late fall garden.

What varieties there are to the chrysanthemum, I think, as I look around them in my autumn garden. Some are short and squat, others tall and spindly. There are restrained ones, which carry one bloom only, and there are the voluble expansive ones that bear at least one floret, and sometimes more, on every branch. There are some that hide their beauty in the shadow of the rocks, and there are those that preen out importantly in the sunlight. Chrysanthemums seem to appear to be like people.

How resilient are the mums. I meditate, as I think about their ability to endure all odds, even to the very brink of winter. Rainstorms do not faze them; their little heads remain erect after sudden downpours. Cold weather does not kill them; they continue blooming until cold or freezing temperatures set in.

Am I equally triumphant? I sometimes wonder—able to hold my head up high after a storm? Can I suffer shock and have it alter me by no more than a tear or raindrop on my petals? Am I so much attuned to nature that none of her surprises can deflate me?

As I stroll around my garden looking at chrysanthemums, I suddenly realize that I make a comparison of one chrysanthemum against others of its class. I am not comparing the chrysanthemum with iris, lilies, or with any other flowering species which have other flowering seasons. In a word, the chrysanthemums are not competing against other flowers outside of their own class.

And then I wonder—do I always evaluate myself against others in my own group? Or do I make an effort to compete with those much younger? Do I always see myself in comparison with others of my years? Or do I sometimes try to share the sun with others half my age? Do I, like the chrysanthemum, enjoy and proudly wear the blessings and the radiances which time bestows upon me?

Chinese art history is replete with references to the chrysanthemum. It is a favorite theme in poetry and painting, and it is a frequent design motif on textiles and on porcelain. The chrysanthemum is generally associated with a life of ease, and the ninth moon (September) is known as Chrysanthemum Month, when it is customary to make excursions into the country to admire the beautiful blooms.

The chrysanthemum appears to resemble people. But how many people are able to incorporate the wisdom and the maturity of the chrysanthemum?

WEN ZHENGMING
After a Long Summer Rain
China, Ming dynasty (1368–1644)
Folding fan mounted as an album leaf;
ink on gold-flecked paper
6⅜ x 19½ in.
The Metropolitan Museum of Art, New York,
Bequest of John M. Crawford Jr., 1988 (1989.363.1)
Image copyright © The Metropolitan Museum of
Art. Image source: Art Resource, NY

An Ancient Alliance

January 14, 1976

I find myself drawn to fans, to fan paintings, and to trees; and there are times when all seem of the same stock.

I look out often on my garden and with a shock of recognition focus on the high heads of oak trees, which suddenly appear like a host of fans. They billow out toward the top in a voluptuousness of great convex cascades. Barren now, their branches are dark slivers against an azure sky, sharp and deft and strangely calligraphic. It is almost as though some Chinese artist had walked into my place and painted there for me an Oriental treat.

What is it, I wonder, that gives this unmistakably fanlike shape of highest oak trees its peculiar meaning for me? Why is it that I feel this sense of ecstasy on observing the kinship of the oak tree to the fan? And what is my comprehension of the fan that it should be to me such a source of delirious delight to fancy it in the structure of my tallest trees?

Integrally rooted to the very core of Chinese philosophic thought, the fan is one of the basic appurtenances of Taoism, China's fifth-century B.C. interpretation of man and his world. The fan is the emblem of Chung-li Ch'uan, one of the Taoist "Eight Immortals." I think that the fan was then, and is still, viewed as one of the stratagems through which man allies himself with nature. Its ability to stir up breezes by an accelerated confluence of the passive and the active is yet another instance of the pervasive yin and yang.

And then I look back to my oak trees and realize that they, too, are waving in the breezes—and observe that they not only have the appearance, but also the movement, of paper fans!

For thousands of years, Chinese artists have used paper fans as backgrounds for their paintings. Fan painting became a vogue in the Ming dynasty (1368–1644), and among the artists who worked in the genre are some of the most illustrious names in the history of Chinese art. Among them, Shen Chou, Wen Cheng-ming, and Lu Chih frequently painted both calligraphy and landscapes upon fans.

Besides giving rise to one of the loveliest aspects of Chinese painting, the fan has long permeated Chinese custom. The fan dance has for centuries been a highlight of the theater, and those who dance superbly with the fans are regarded as national stars. But fans also make a public appearance annually in the late spring, when men, woman, and children resort to them for the practical use of cooling off in the warm weather.

Sometimes I think wistfully of how the discreet fan has, for so many centuries and in so many ways, exercised a spell of wisdom and of wonder (as well as practicality) for countless Chinese people. How wonderful it would be if we, too, in our own time, could fan our special energies and talents into enduring inspirations.

A Round Personal Equation

September 18, 1980

The Chinese are in love with the idea of roundness. To them it symbolizes continuity.

Their Temple of Heaven in Peking, with a triple roof of Ming, or royal, blue melting into the sky of a late afternoon, is round. So is their "bee," or symbol of heaven, generally fashioned of jade and used over the centuries by emperors in their prayers for annual harvests.

Their favorite gifts are bracelets. And, their favorite foods appear to be apples and oranges.

On a recent trip to China, I was served apples and oranges at almost every meal in all six cities I visited. Markets everywhere have large open stalls with huge bins of apples and oranges. And I remember purchasing a tangerine to enjoy while observing the compelling vista of West Lake in Hangchou.

I think that this painting of Chu-ta, *Moon and Watermelon*, is in line with the Chinese romancing of the idea of roundness.

Chu-ta (1626–1706), one of the great artists of the Ch'ing dynasty (1644–1912), was a descendant of the Ming imperial family (1368–1644); and upon the fall of the Ming dynasty, when he was about twenty, he became a Buddhist monk.

His paintings are strong, highly personalized, and impressionistic. He has great originality, great dash, and economical flair, combined with fine control and a deceptive ease.

I think that Chu-ta was drawn to the subject of *Moon and Watermelon* on several counts. As a Chinese, he was not only fond of the subject of roundness, but also of the moon (a fondness common in China). And, as a Buddhist, he was drawn to the fruits of the earth, in line with the "witness the earth" position, one of the more common positions of the Buddha, in Buddhist iconography.

But somehow I think that there is more to this sparse, contemporary, and rather witty painting by Chu-ta. The inclusion of the watermelon into the orbit of the moon suggests an intimacy of the relationship, a sharing of a common bond. It is the high water content of the melon that brings it into the yin family of water and the moon.

And while the main thrust of the relationship is between the melon and the moon, I feel that there is also, in the momentary departure from rotundity, a suggestion of closeness to the earth. The outward-downward movement of the lower right, with a straighter linear eventuation, suggests to me the melon's resting on the earth. Chu-ta not only describes his melon as in closest relationship with the moon, he brings it at the same time into contact with the earth.

The picture then becomes not anything apart, remote, distant from us, but an integral projection of us. Like the melon, we, too, incorporate the water and we lean upon the land. *Moon and Watermelon* becomes a mirror of us—another example of the immediacy of Chinese art, and of its personal equation.

ZHU DA (also known as Bada Shanren)
Moon and Melon
China, ca. 1689
Hanging scroll; ink on paper, with signature reading "Bada Shanren"
Image: 29 x 17¾ in.; mount including cord and roller ends: 82½ x 25¾ in.
Harvard Art Museums/Arthur M. Sackler Museum, Gift of Earl Morse, Harvard Law School, Class of 1930 (1964.94)
Photo: Imaging Department © President and Fellows of Harvard College

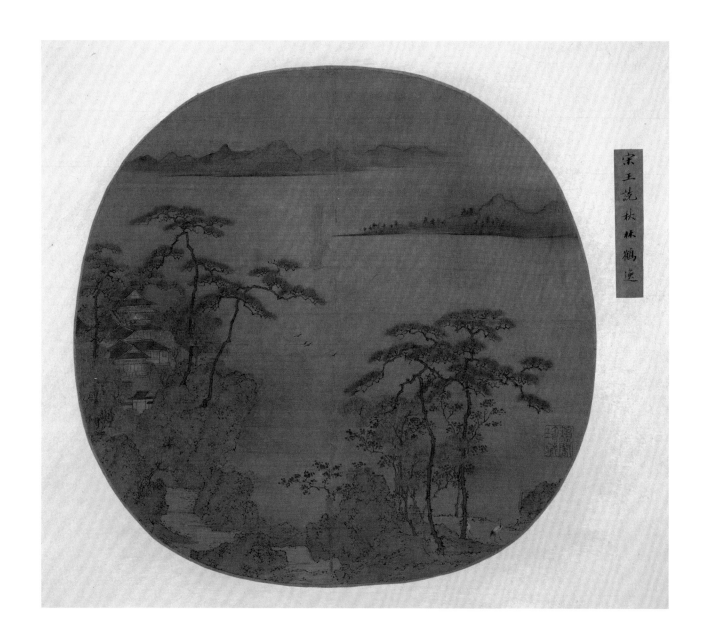

宋玉洗秋林鶴浹

UNIDENTIFIED ARTIST
Landscape with Pavilions and Cranes
China, Late Yuan dynasty (1271–1368) or
early Ming dynasty (1368–1644)
Fan mounted as an album leaf; ink and
color on silk
9 ¾ x 10 in.
The Metropolitan Museum of Art,
New York (47.18.43a) Image copyright ©
The Metropolitan Museum of Art. Image
source: Art Resource, NY

On Land and Water, Symbols of Longevity

March 12, 1980

The Chinese feel that the crane symbolizes longevity, and they believe that it can live to be six hundred years old.

A pair of cranes disports themselves around one of my little garden pools. To me, they are easily construed as symbols of longevity because they stand upon the eternal substance of the land. They seem to observe and enjoy the slow trickle-trickle of a minute waterfall, as drop by drop it finds its way across a flat-topped rock, eventually to fill up the pool.

The cranes flank the scene, and they help to make it one of the loveliest in the garden. About their feet, unsummoned and like weeds, pop up great spiky wildflowers, of tall conical shape, bright blue in the springtime and browning in the fall.

To me, the cranes are auspicious symbols in part because they are positioned in the garden in a spot where I myself most like to be. They contemplate the measured tread of the infinitely beautiful and healing waters, and the very spot they occupy is radiant with unbeckoned bounty from nature's infinite resources.

My cranes are garden variety, inexpensively acquired long ago from a neighboring vendor specializing in garden ornaments. They are cast in metal and painted in white. But there is something about the slender elongation of their shape which is, to me, both elegant and provocative.

Cranes seem to me of very special beauty. Their high-arched backs, long slender necks, and quizzical small heads rise upward from tall slender stovepipes of thin legs. Their beaks, stubby and short, like exclamation points, give extra verve and drama to their statement.

Not only do cranes unite a balance of the horizontal with the vertical. The thinness of their legs contrasts with the squat stubbiness of their bodies, and the attenuation of their necks balances the shortness of their heads. And all of these dichotomies seem to represent the ancient dramatic unity of the opposites. The crane is a figure in which high and broad, long and short, thin and fat appear and reappear, and in a unity that is forever both aesthetically and philosophically viable.

One of the most celebrated birds in Chinese legends, the crane enjoys an eminent present as well as an illustrious past. It has an extremely high visibility, both in Chinese arts and Chinese crafts, and is everywhere noticeable both at home and abroad. It appears in Chinese jade, Chinese painting, and Chinese porcelain. It occupies an important spot in a courtyard of the former Imperial Palace in Peking, which dates back to the emperor Yung Lo (1403–1424) of the Ming dynasty (1368–1644). It is sold across the counter as a paper cutout at the railroad station in Shanghai.

In China, the crane is the friend of all the people, not merely the intellectually or artistically elite. It is attractive to all, and it is accessible to all. It is an old, forever new companion to the most populous nation on earth.

Where My Changing Heart Is

March 27, 1979

In my ecstasy at returning always to my home, I am reminded of the great Chinese poet, T'ao Yuan-ming, who wrote, in the fifth century, in a poem called "Homecoming": "Now my eyes light upon my door and the ridge of the roof. Exultingly I hasten forward."

I wonder what there is about my home (and about the home of T'ao Yuan-ming, and of everybody else) that is so compelling? Why is it that when I approach my home, after having been away from it for only a few days, my heart beats faster and my senses sing?

My home, as was the home of T'ao Yuan-ming, is irrevocably associated with a garden. In my home, together with my garden, I feel myself at one with nature. There is a flowering pattern in the garden that is familiar, yet always new. The air is high and dry, and a pregnant moody silence seems to charge the very atmosphere with happy intrigue.

The interior of my home is, in itself, a garden within a garden. It is full of memorabilia, full of treasures and absurdities, full as an ancient storehouse of simple but rich living. There are throwbacks to my California origins, in ancestral hand-me-downs . . . souvenirs of European and Asian influences that I have been exposed to . . . and even a few representations of contemporary cultures.

Still, my home is more than that. Many of the objects in my home, and perhaps the ones which most give my home its meaning, are objects which retain a sense of nature, and which, even when only glanced at—like paintings of the sea—immediately transport me to the world of nature.

Still, my home is even more than that. It is not only a static thing; it is a dynamic vital thing. It is not only where my changing heart is, it is also where my changing mind is, my changing spirit—where the totality is of my experience, my ambition, my achievement.

Home is where I can most easily encounter, appreciate, and evaluate the confluence of the strands that are my life. Home is where I most easily and naturally confront the new and old, the brash and worn, the tried and avant-garde.

My home keeps me in a constant state of wonder at its wonderfulness. In winter, there is the velvety virginal mantle of the snow; in spring, the sign of the new crocus; in summer, the smiling bland face of the moon; and in fall, the crisp coppery turnings of the foliage.

"Exultingly I hasten forward."

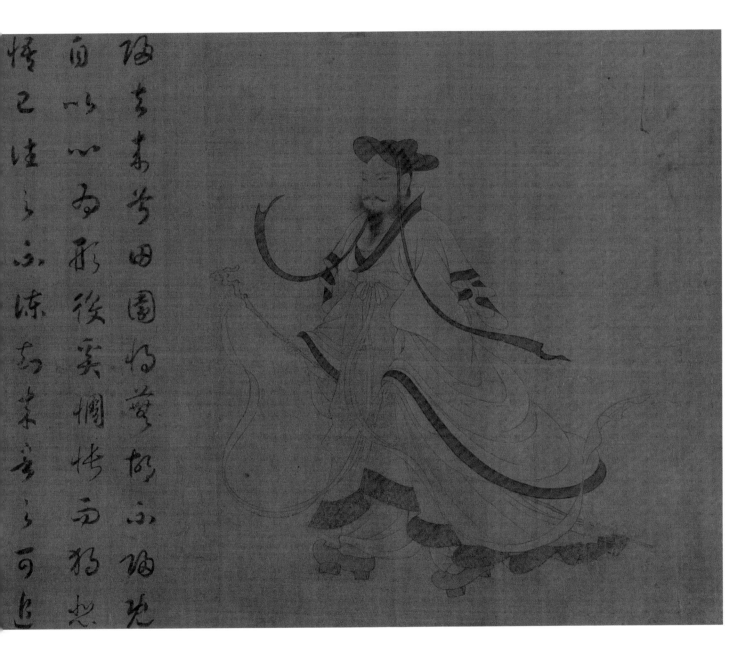

UNIDENTIFIED ARTIST
Illustrations to Tao Qian's Prose Poem Homecoming (detail)
China, Southern Song dynasty (1127–1279)
Ink and color on silk
11¹³⁄₁₆ x 172¹¹⁄₁₆ in.
Museum of Fine Arts, Boston, Special Chinese and Japanese Fund (20.757)
Photograph © 2016 Museum of Fine Arts, Boston

THE FAR VIEW

Journey to the East:
The People's Republic of China

My first trip to the People's Republic of China was a cultural trip, under the auspices of the China Institute in America. Actually, it was a trip somehow of my own making. I had said earlier to K. Y. Ai, director of the institute, that I wished there were some trip that would take one to the scenic centers of Soochou, Hangchou, and Kweilin. And when, later, the institute offered this very trip—along with Shanghai, Peking, and Canton—I eagerly signed up.

Soochou, a major city in the southeast of Kiangsu province, was fascinating. On the one hand was the spell of the ancient artists, Shen Chou and Wen Cheng-ming of the Ming dynasty, on the other was the intrigue of the famous gardens, also dating back to Ming times.

The city itself was beautiful with its whitewashed houses, brown-tiled roofs, arching sycamore trees, and canals. The Grand Canal, viewed on a foggy morning with its gliding river craft, was especially picturesque. It tied in happily with the handscrolls and album leaves by Shen Chou and Wen Cheng-ming which I later saw at the Soochou Museum.

We visited the Master of the Nets Garden, the Liu Yuan, and the Humble Administrator's Garden. Their features of architecture, galleried walks, water, moon gates, and bridges were a continuing delight.

Our second destination, Hangchou, was China's capital during the Southern Sung. It was also the home of the greatest landscape artists of all time: Ma Yuan and Hsia Kuei. Thinking back to the paintings of these artists gave added meaning to the joy I derived from meditating on the West Lake, and on its superb vistas.

We took a boat ride one afternoon, in an open launch, in which the lake seemed to open up like a landscape handscroll. First we passed a series of villas on the lakeshore; then the elongated bridge, guarded over in the background by a pagoda; then the openness of the water and distant hills, with a small and single boat plying its way in the foreground; and finally, the three "towers that reflect the moon."

Leaving the lake, we ambled through a park, and I was surprised to see a monstrous sculptured fish, in Chinese red, perhaps fifteen feet tall, leaning against a tree, his head scaling the trunk. He was a winsome fellow, and he carried my mind back to "the fish which has the strength to swim against the tide."

I was very much interested in our visit to the Lingyin Buddhist temple and the rock carvings at the adjacent "Peak Flying from Afar." The spectacle of the guardians in the temple reminded me of my first sight of a fearsome guardian figure, many years ago, at the gallery of a Chinese art dealer in Tokyo. At the time, I did not understand the meaning of the guardian as protective; since I have learned the meaning of the figures, I can only enjoy them more.

The Buddhist rock carvings were varied and delightful. Countless Buddhas stared out, laughed, and postured in all variations of *mudras*, or hand positions. I was very much gratified to come across one in the attitude of "abbaya mudra," with one hand raised in strength and the other outstretched in compassion.

My first encounter with a Buddha figurine came via the eminent art dealer C. T. Loo from Shanghai. I made the acquaintance of Mr. Loo through the photographer Arnold

Opposite: LIU LIQUN, **Spring Snow at the Summer Palace in Beijing**
China, Copyright © Liu Liqun/Corbis

Above: An old envelope with stamps from China, Chinese characters, and a wasp
Copyright © ImageZoo/Corbis

Genthe, for whom I had often sat for portraits. Genthe and I became dear friends, due to our love of Chinatown in San Francisco, which he had often photographed.

From my very first visit to the showroom and offices of C. T. Loo, on the second floor of the Fuller Building at Madison and 57th Street, I was enchanted. The spacious showrooms were flanked with glowing jades and porcelains, and figurines in softly illuminated cases.

In the little room where Mr. Loo and I had our tea, there was a small figure, not much more than a foot high, seated high up on the wall on a projecting shelf. My eye traveled always to this figure, even in the midst of conversation. It fascinated me. It gave me peace, as much peace as I have every known. It had a benign smile, a funny little topknot atop its head, and there was a linear fluidity to its body. It was graceful and it was beautiful. But, it was more than that. It was holy and it was gracious, and it seemed strangely forgiving and strangely inspiring. It was captivating.

Finally, I got the courage and asked, "I wonder if I could ever have anything so beautiful as that?" "If you and your husband like it, you can have it," he came back unhesitatingly.

So we purchased it, for seven hundred dollars. It has been worth its weight in gold—as a household mentor, as a constant unfailing inspiration and guideline to life, as well as an undiminishing aesthetic delight. It is a source of inexhaustible beauty.

Our Buddha is stone. It is of the Wei period, of the sixth century, from the Lungmen caves. It has the halo of great wisdom, the elongated earlobes of great wisdom, the thin-lipped, semidimpled archaic smile, and it sits in the cross-legged position on the lotus leaf.

Witnessing this powerful *mudra* on the Buddha carvings here, so far from home, brought to mind the Guatama Buddha, whom I studied years ago. The Guatama Buddha had escaped from worldliness to nature; he left his wife, home, and material possessions to receive enlightenment out in the fresh air, beneath a tree.

Wasn't this voyage for me a symbolic journey on my own path toward enlightenment?

Kweilin brought us to the mountains of the River Li, which we traversed one day by boat. Whereas the West Lake of Hangchou had been soft, evocative, and insinuating, the River Li was strong, formidable, and powerful. It was the difference between Southern Sung and Northern Sung in landscape painting. It also was the difference between the yin and the yang.

As a matter of fact, the whole city of Kweilin, viewed from my hotel window, looked like a variation on the theme of landscape painting. Here was nature, in the form of the fantastic mountains; and here was man, represented by clusters of low-slung rectangular buildings. And the two were integrated, with the buildings seemingly built into the foothills of the mountains.

Shanghai had a warm air of informality. Somehow it reminded me of my "own" Chinatown, an ocean away in San Francisco. My room at the Jin Jiang Hotel overlooked a broad lawn, with a pavilion semiobscured by trees at the far end, and clumps of trees with garden seats at their bases in the foreground.

We saw the famous Bund, which has been so often photographed, and we shopped at the Number One Department Store on Nanking Road.

We also visited the Shanghai Antique & Curio Store, where I purchased a small handscroll painted in traditional style by Pu Xinyu (Puru), a cousin of the last emperor. It shows a family of three sitting on a porch and looking at—in sequence—a rock, a tree, and some water. This is precisely how my family of three (my husband, our daughter, and myself) sits and what we look at, in our garden back in New York.

Our visit to the Shanghai Museum was especially rewarding. Having a bronze Shang-dynasty tripod *chu-eh*, I was much interested in seeing their fine collection of bronze vessels, including *chu-ehs*. I reminded myself of the historic use of the bronzes in ancestral rites, and I enjoyed observing the variations of the decorative motifs, including the cloud-and-thunder pattern and the *t'ao-t'ieh* (mythical creatures with gaping mouths).

We visited a jade factory and a carpet factory. And both of them were, to me, happy illustrations of the fact that objects being produced today are continuing the same glorious tradition which has so much distinguished the arts of ancient China.

Our first stop in Peking was the Temple of Heaven. The late afternoon of the setting sun gave a golden radiance to its concentricity. I thought of the significance of this beautiful round building over so many centuries . . . of how the emperors there performed their annual prayers for bountiful harvests . . . and of how important the concept of circularity as a good omen has been to the Chinese people.

We went up Ch'ang-an Boulevard to Tiananmen Square to see the Gugung. It seemed to me that the entire compilation of ancient Chinese glories was here—in a

unique interrelationship of architecture, art, and nature. I particularly enjoyed the crane and the tortoise, both symbols of longevity and both of which I have at home, in the Hall of Supreme Harmony. And in the Treasure House, I was surprised to come across a case of my favorite jade *ruyi* (scepters). It was also with special pleasure that I entered the lovely garden at the rear of the Gugung, and recalled the horticultural enthusiasms of the emperors Hui-tsung and Ch'ien Lung.

The trip to the Great Wall was a great experience for all of us. It was a reminder of the courage, strength, and indomitable spirit of the Chinese people. I thought back to a picture of the Great Wall, which today is on exhibit in New York at the United Nations. And I thought of how properly symbolical it is, of cooperative endeavor.

Canton, where we were to end our trip, was a short stop, shorter than I would have wished, but long enough to show it as a winter wonderland. The sun shone brightly, and purple-flowering trees were everywhere. We got a glimpse of the Pearl River, lunched on *dim sum* at the palatial Pan Hsi restaurant, and strolled through Yue Hsi Park, enjoying its lakes and arch as well as its flowers.

It was chrysanthemum time, and the displays in the park were spectacular. There was even a stupendous dragon, perhaps twenty feet tall, his head twisting to-and-fro to lively musical accompaniment; and he was made almost entirely out of flowers.

We stayed at the new White Cloud Hotel in Canton, a very modern thirty-story skyscraper. As we were about to leave, I looked out of the window by the elevator on the twenty-fourth floor. Mist was rising over distant Canton hills.

Was it a view to which I would one day return?

I hoped so.

LUDOVIC MAISANT, Feilai Feng Caves beside Lingyin Temple with Budai sculpture "The Cheerful Buddha," 10th–13th centuries, Hangzhou China, Copyright © Maisant Ludovic/Hemis/Corbis

居于家中，坐于树下
原载于《基督教科学箴言报》1981 年 10 月 21 日

我的一个中国朋友曾经告诉我："我们中国人可以是道家、儒家和佛家——我们可以同时是三者！"

当中国人在自家的花园里将自己的心灵与自然合为一体时，他们是道家。当他们身处家庭之中与人为善时，他们是儒家。而当他们在安静的时刻回顾生命的历程并温习佛教的经典时，他们又成了佛家。

在我看来，道教、儒教和佛教在对待自然的态度上彼此共通。道教之父老子说："如果你想发现和平和宁静，就回归自然。"孔子说："人与自然和平相处。"而佛陀则舍弃了舒适的家居生活，在一棵树下达到了悟证。

很有可能，正是这三种哲学方式的共通之处——也就是对自然的重视——使得中国人可以同时接受它们。

我相信自然本身就是三种中国哲学的真正庙宇，而中国思想的真正核心就在于室外的自然。在那里，树是信仰的支柱和尖顶。

中国人接受了这种简单而直接的自然力量，并将它转换成艺术。所有这些艺术作品都有一个自然的主题，它们自身其实就是大自然的提炼。中国山水画的道教因素表现在人与自然的统一，也表现在这些画作的物质成分——比如用桑树皮为原料制作的画纸和用柏树灰制作的墨——都来于自然。儒教的思想则通过那些在巨石和山溪之间找到的玉石来表现，那些珠宝被认为是代表了最精致的士人的特征。而佛教则对中国的雕塑艺术有很大的启发，尤其是安坐在莲花之上的佛陀像，它象征着佛与自然世界的不可分割。

因此，要做一个汉学家，就必须是居于家中，坐于树下——就像佛陀所为，也是老子和孔子的教诲。这是一种有说服力的思想，对我们大多数人来说也是神奇地自然而然。

At Home under a Tree

October 21, 1981

A Chinese friend of mine once said to me, "We Chinese can be Taoists, Confucianists, and Buddhists—all at the same time!"

The Chinese can be Taoists in their gardens when they invite their souls and meditate on their at-one-ness with nature. They can be Confucianists in their families when they adhere to good behavior. They can be Buddhists in their quiet moments when they evaluate their lifestyles, aware of Buddhist laws or sutras.

It seems to me that Taoism, Confucianism, and Buddhism come together on the common ground of nature. "Return to nature," said Lao-tzu, father of Taoism, "if you would find peace and serenity." "Man and nature go together," said Confucius. And the Buddha forsook a comfortable home to find enlightenment under a tree.

It may well be the similarity in the three approaches—that is, the basic nature-orientation which they share—that makes it possible for the Chinese to embrace all three of them at one and the same time.

I think that nature itself is the real temple for the three major Chinese ideologies and that the real heart of Chinese teaching is the out-of-doors where trees are the cornerstones and the spires of the people's faith.

The Chinese have taken this simple natural force and translated it into their fine arts, all of which carry out the theme of nature and are in fact themselves distillations of nature. Taoism is expressed in Chinese landscape painting, in which man finds himself as part of nature and in which the very materials—such as paper from the mulberry bush and ink from pine-tree soot—are based in nature. Confucianism shimmers through in beautiful jades that are found in boulders, hills, and streams and are thought to reflect the characteristics of the finest gentlemen. And Buddhism has inspired Chinese Buddhist sculpture, in which the Buddha sits upon a lotus plant to reveal his indivisibility from the natural world.

To be a sinologist, then, means to be at home under a tree—as was the Buddha, as was commanded by Lao-tzu, as was advocated by Confucius. This is a compelling thought, wonderfully natural to most of us.

"At Home Under a Tree"
translated Chinese

Rhapsody to Spring

June 10, 1977

The Chinese have a word for their spring festival. They call it the Chi'ng Ming ... It symbolizes the return to nature, the renewed predisposition to the out-of-doors.

Sometimes, I think how closely I stand to the Ch'ing Ming ... as I run out into my garden feeling the gentle, benevolent sun upon my back ... the gentle breezes on my face ... the gentle soil beneath my feet, as I celebrate a renewed closeness with all nature.

We know much about the Chinese feeling for the spring, not only from Chinese poetry but also from Chinese painting—and especially from one particular Chinese painting, a handscroll that was originally painted in Sung times (960–1279), and of which a later Qing copy (1644–1911) is in the New York collection of the Metropolitan Museum of Art.

The "Ch'ing Ming" handscroll, though anonymously painted, is nonetheless vibrant with a touch of magic. It seems to blend all of humanity into great chords to celebrate the springtime. It works up, gradually but powerfully, almost symphonic in its development, until the total world seems to be involved in a colossal rhapsody to the spring.

The monumental handscroll, over thirty feet in length, takes place in the springtime and in the vicinity of a river. In fact, its actual title, apart from the easy reference of "Ch'ing Ming," is *Spring Festival on*

the River. It shows hosts of little people engaged in a myriad of pleasurable activities.

They are sipping in open-air teahouses, shopping in furniture stores. They are on foot and on horseback and in boats. They are participating in, and being spectators at, parades. They are children and adults and aged. They are rich and poor. They are happy. They are universal—as they pursue their merry springtime way, blossoms flower above their heads and under their feet the river slowly meanders. I think how naturally my own little garden, with its sequence of pools and brooks, affords me, too, today, the experience of Ch'ing Ming. It propels its own leisurely course, and I mine, as I wend my way along its nooks and crannies, sharing in my own "parade," my own multitudinous pleasures and delights.

And, then, I think back to thee

Ch'ing Ming handscroll, and wonder if some of its appeal for me may not lie in its supportiveness to my own lifestyle. Is it not quite possible that I, in my own flamboyant self-relinquishment to nature in the springtime, derive support from the knowledge that what I do and how I feel is a mere carry-over of what the old Chinese did, almost a thousand years ago? Do I not find, as I move into the handscroll of Ch'ing Ming, supportive measures, almost like finding my own ancestors?

And suddenly I realize that I am not alone in my sense of exuberance about the springtime. The old Chinese long antedated my full-blown sense of seasonal freedom.

And is it not a clarification, for all of us, of our own attitudes—to realize that we are drawn, in spring, to the out-of-doors in precisely the same way that man has been so drawn since time began?

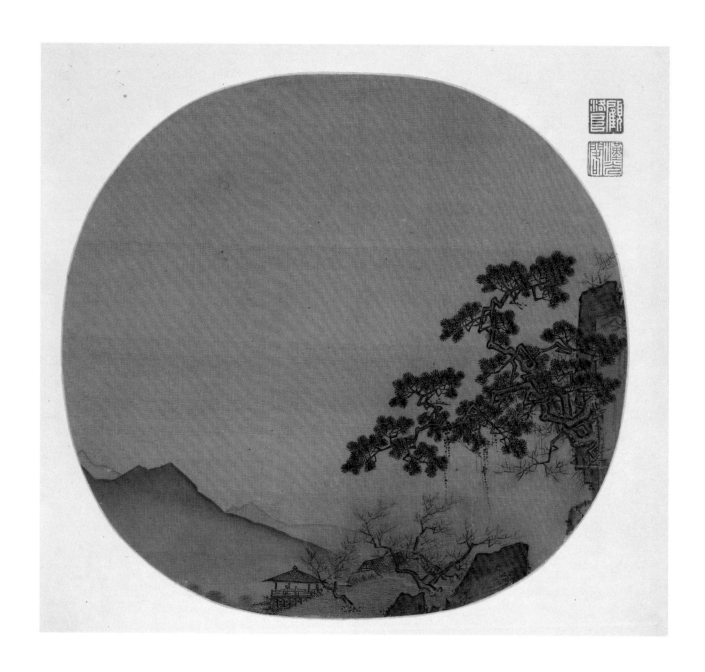

FORMERLY ATTRIBUTED TO LIU SONGNIAN
Evening in the Spring Hills
China, Southern Song dynasty (1127–1279)
Fan mounted as an album leaf; ink and color on silk
9¾ x 10¼ in.
The Metropolitan Museum of Art, New York, Gift
of John M. Crawford Jr., in honor of Alfreda Murck,
1986 (1986.493.1)
Image Copyright © The Metropolitan Museum of
Art. Image source: Art Resource, NY

Being in the Midst of Life: Symbols

May 30, 1980

Chinese landscape painting is full of symbols that stand for man. Even if there is no figure in the painting, man is there, by implication.

Sometimes the symbol for man may be a house. Or a boat. Or a bench. Or a bridge . . . a pavilion . . . a pagoda.

One cannot conceive of a house or a boat or a bench without at the same time thinking of a man. It is man who has made these objects. And so the inclusion of the structures in the painting suggests the presence of man, just as much as if he actually were there.

I think of how true this is, also, in my scenic wanderings in suburbia, not far from my own home. There is a lake with a lone bench at its shore, a river with a rustic bridge, an inlet overlooked by strangely Chinese-styled pavilions. The bench, the bridge, and the pavilions suggest man.

Often, as I view these favorite spots of countryside tranquility, I am reminded of the kinship of these spots with Chinese landscape painting. They all lure man, whose presence is implied by various symbols, to nature and with it, to peace and to repose, in a concept as ancient and as prophetic as the fifth-century B.C. writings of the Chinese philosopher Lao-tzu.

Sometimes I sit upon a bench, look out from a pavilion, or walk across a bridge and I feel myself moving into a Chinese landscape painting, even though the locale happens to be American. This is not only because the field of Chinese landscape painting is my bias, but because it was the Chinese artist who, a thousand years ago, coordinated man to nature by symbol as well as by actuality.

I remember, on my recent trip to China, photographing a bench that looked out on a splendid scene in Yue Hsi Park in Canton. Purple flowering trees framed the insinuating view of a calm lake. A distant island played host to an airy building with columns in fire red. I felt that the bench, at a low, inconspicuous overlook, at once stood for man and invited man to share in the compelling vista.

Evening in the Spring Hills, a painting from the Southern Sung dynasty (1127–1279), shows a pavilion nestled in the hills as focal point.

The pavilion by itself would serve as a representative of human life, even if the two almost imperceptible figures inside it were not there.

Apart from the pavilion, *Evening in the Spring Hills* correlates a wealth of provocative design. Low, pale gradations to the left contrast pleasingly with the twisting high tree to the right. Horizontality contrasts with the verticality. Soft uniformity contrasts with tortured sharpness. The light contrasts with the dark. And man, in the symbol of the pavilion, finds himself between two extremes—gentleness and softness on the one hand, drama and excitement on the other. A design of human life?

Sometimes I am reminded of modern Chinese artists who say they "write" their paintings. If they "write" their paintings, through their dexterous use of the brush, do we not "read" their paintings through some slight comprehension of their symbolism, their meaning, and their universality?

臨孫克弘石上蘭

UNIDENTIFIED ARTIST
Orchid on Rocks
China, Qing dynasty (1644–1911)
Color woodblock print
11½ x 9⅘ in.
The Cleveland Museum of Art,
Edward L. Whittemore Fund (1908.171)
Photography © the Cleveland Museum of Art

A Modest Flower

June 9, 1978

The orchid, to the Chinese, stands for the charming gentleman.

The Chinese orchid, whether in nature or in art, is a modest flower. So modest, almost invisible. It makes the viewer look for it. It has five tiny little petals, perhaps a quarter of an inch across and at the very most one inch long, often striated in contrasting color. The petals generally are green, or orange. Sometimes they are soft yellow.

It is not the flower that so much distinguishes the Chinese orchid, as it is the foliage. The foliage of the Chinese orchid is slender and curvaceous. It is of long linear extension, and its flare is often almost semicircular. Sometimes the striking slender leaves appear to twist and turn, and to imply the twisting and the turnings that one encounters in the conduct of a life.

I think with interest about the beauties of the Chinese orchid—and of how it has become more philosophical than ostentatious. And I think about how, by contrast, our Western "orchid" is all gaudiness and costliness and show.

Long one of the favorite themes of Chinese artists, the Chinese orchid is frequently referred to as one of the "Four Gentlemen"—along with the plum blossom, the bamboo, and the chrysanthemum. Confucius, in the fifth century B.C., called it the emblem of the superior man, symbolic of his humility, retiring nature, and great refinement. It has been painted over the centuries by many of the celebrated masters of Chinese art, and here we illustrate it with *Orchid on Rocks*. I think of how the Chinese

orchid is not only small and modest, but of how the Chinese orchid displays itself through its foliage, thus making its byproduct become a vital factor. And then I wonder, why must we, in our version of the orchid, develop and display the flower as a symbol of extravagance, concentrate on startling size, and ignore the foliage?

Can we not properly assume that, in calling all attention to the flower in itself, and in regarding it as elitist and materialistic, we convey once more the egotistic tenet of our society? And that, were we instead to cultivate beautiful "leaves"—beautiful appendages—we might create (as do the Chinese, with their orchid) not only a total beauty, but also a philosophic attitude which could yield us a sense of generous well-being?

MI FU
The Pavilion of Rising Clouds
China, Southern Song dynasty or
Yuan dynasty (1127–1279)
Ink on silk
59 x 31 in.
Freer Gallery of Art, Smithsonian
Institution, Washington, D.C., Gift of
Charles Lang Freer (F1914.53)

Airy Agent of Change

August 14, 1979

Fog, which lends so much variety to our own visual world, is a major element in Chinese landscape painting.

How dramatic is the fog, I think on some early mornings, when I look out on my garden and see an opaque screen of gray—on those times when nothing can be seen beyond the fog—and then slowly, very slowly, a ray of sunlight filters through to release the shapes of trees and ponds and sky.

The lifting of the fog is as magical as it seems. Slowly, very slowly, the accepted realities of the world reassert themselves. And one comes to wonder, what is the ultimate reality?

Sometimes, I think I like my garden best in lifting fog, when trees are bisected by pale gray mists, when far into the distance the tenor of the world is grayed, with little bits of green here and there emerging.

The fog, which has played so vast a role in Chinese landscape painting, is, with its semiaqueous composition, affiliated with the yin motif, of which a salient symbol is the water. It is soft, as its textural qualities address the eye. It is damp, as its semiliquid properties address the skin. And, it is ever moving.

I think it is the constant mobility of the fog which has so much intrigued centuries of Chinese landscape artists. The fog has the power, in its delicacy and in its airiness, to transform the physical world.

This picture typifies the Mi style of fog-drenched terrain, which—in the Sung dynasty (960–1279)—became an established mode for Chinese landscape painting, under the influence of Mi Yu-Jen (1086–1165) and his father Mi Fu (1052–1109).

Sometimes I think of the theatrical properties of the fog, of how it changes scenes, alters reality, and makes of itself a momentary star.

Sometimes I think of its entertaining aspects, of how from time to time it changes our viewpoint of the world in its endless variety of appearances and moods.

Sometimes I think of its aesthetic aspect, and of how it alters the customary everyday world into new guises of its own—new shapes, new beauties—all of them transient, yet lovely while they last.

Sometimes I think of its philosophic aspect, and wonder why the fog has more power than violent thunder to transform the world . . . perhaps the fact of its immense strength is concealed within its guise of serene softness.

And finally, I am reminded of the Chinese concept of "change" as basic to all things. And I wonder if the changeability wrought by the fog on the visual world—intriguing, provocative, fascinating as it is—may not be a suggestion that change may be a good omen in all of nature, including our own lives?

UNIDENTIFIED ARTIST IN THE STYLE OF XIA GUI
River Landscape with Boatman
China, Ming dynasty (1368–1644)
Fan mounted as an album leaf; ink on silk
9⅛ x 9½in.
Image Copyright © The Metropolitan Museum of Art.
Image source: Art Resource, NY

To and Fro with the Wind

July 16, 1979

In their constant explorations into the field of nature, Chinese landscape artists frequently depict the wind.

Here we feel the ferocity of its force, as it propels two boatmen toward a river's edge. They are going with the wind. They are being pushed by it, aided by it in their efforts to reach land.

It is a dark afternoon, and perhaps late in the season of the year.

The sharp calligraphic linear depiction of the pair, and of their craft, is heightened in attention value by being contrasted with the washed-out subtlety of the surrounding scene.

One can feel the gusts of wind. Once can also admire the dexterity and precision of the artist's two-fold technique—of sharp detail and of soft panorama.

We know that the wind will change, and that it will blow in the opposite direction. We also know that, were the men in the little boat to change their course, they would be going against, instead of with, the wind.

Sometimes from my home I watch the wind, jostling and tossing the branches of the trees. And I think how sensible and intuitive are the branches—not to try to go against the wind, but to go with it, to go with nature in whatever is the order of the day.

Sometimes the wind is gentle, like a little breeze. Sometimes it is violent, fierce, and forceful. Whatever its guise, it alters the posture of the branches, but only briefly, until stability and harmony return again.

And so I feel it is with our own lives. The to-and-fro movements of the wind represent the rights and lefts, the yang and yin that affect us all.

The sense of contrast implied by yang and yin is evidenced here not only by the wind, which, as we all know from our own experience is of alternating repercussions. It is also conveyed, compositionally and technically, by the dramatic technique of contrast the artist has employed. Our eye is drawn irresistibly to the sharp attenuation of dark lines, and then allowed to rest in the floating soft terrain.

Typical of the Southern Sung (1127–1279) landscape painting is the moodiness and grayness of the format, as also is the concentration of design in the lower left, which came to be known as the "one corner" of the Ma-Hsia school. The Ma-Hsia school, celebrated since Southern Sung times, combines the names of its two major artists, Ma Yuan and Hsia Kuei, of whom this example is by a follower of the latter.

I feel that looking at such landscape paintings as *River Landscape with Boatman* comes, even with the slightest comprehension, to be far more than a mere aesthetic pleasure. We come to see the ebbs and flows, the gives and takes, the strengths and weaknesses that are not merely part of art. They are part of life. For all of us.

Beauty of Clouds

December 16, 1976

On a clear, brisk, sunny day, I look up at the clouds, so white, so lyrical against a pale blue sky.

A stripling of a cloud formation appears a mountain range; a puffy rounded cloud is like a ball of cotton. And right before my eyes they change. The "mountain range" becomes a high conical Mount Fuji. The "ball of cotton" elongates into the semblance of a dragon. And following the dragon, in hot pursuit, another formless shape suddenly takes on the aspect of a flying seahorse.

I notice that not only do the shapes of the clouds change from moment to moment and hour to hour, but so, also, do the colors. Toward the sunset, a roseate glow seems to bathe the clouds in shocking pink. And a little later on, the slow darkening of the night brings soft misty bluish grays to take over gradually the pink cloud formations of the sunset. At the dramatic moment of swiftly coming night, the final and remaining rosy cloud formations, pinker now than ever, seem to thrust like land masses into the blackish seascape of the sky.

I think about the easy and natural affinity the changing cloud colors and formations have to the venerable Chinese *I Ching* or "Book of Changes," the original date of which is shrouded in the nebulae of long lost time, but which surely antedated the fifth century B.C. As, according to the *I Ching*, the fact of change appears to characterize all nature and all life, and as I see "cotton balls" changing to "slithering dragons" before my eyes, I reflect upon the changes which have taken place in my own life, in my own experience, since I am, too, a part of nature. I, a city person, became a country person, and the devotee of Western culture swerved to the Oriental—the "cotton ball" which was myself became the "slithering dragon." And today, with a curious enthusiasm, I wonder what next change may lie around my corner.

Clouds, perhaps because of their easy rapport with the content of the celebrated *I Ching*, loom large in Chinese culture. They decorate porcelains, textiles, bronzes, and paintings. Sometimes their representation is formalized and geometric, as in decorations on the bronzes. Sometimes it is fluid and highly personal, as many paintings of the period.

Sometimes, I think about the negativism that we Westerners ascribe to "a cloudy day." Even the term carries a dismal connotation. Then I think how, by contrast, the Chinese find in clouds a source of joy.

Is it not possible that we, too, as well as the old Chinese, may look upon the clouds as filled with amusement and inspiration— as happy original omens of infinite change?

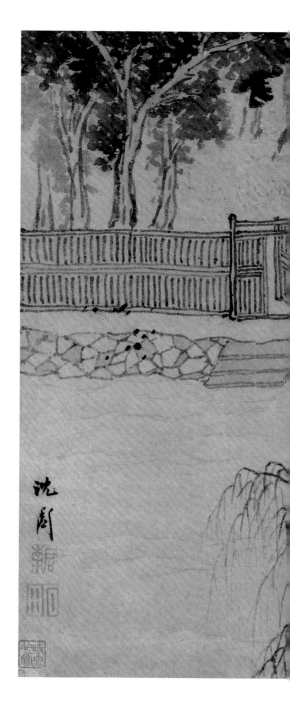

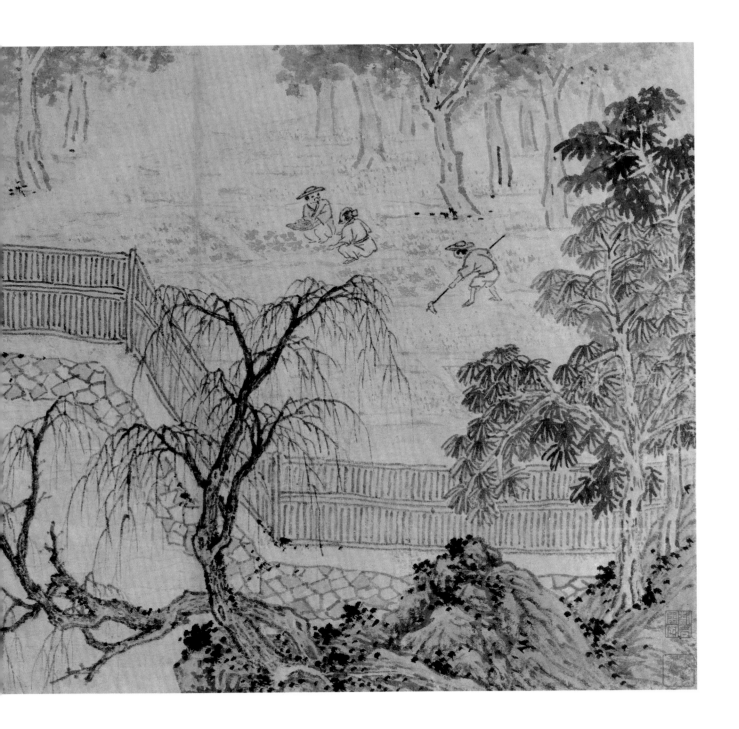

SHEN ZHOU
Gardeners from *Landscape Album: Five Leaves*
by Shen Zhou, One Leaf by Wen Zhengming
China, 1496 (Ming dynasty)
Album leaf mounted as a handscroll: ink on paper
15¼ x 23⅝ in.
The Nelson-Atkins Museum of Art, Kansas City,
Purchase of William Rockhill Nelson Trust (46-51/1)
Photo: John Lamberton

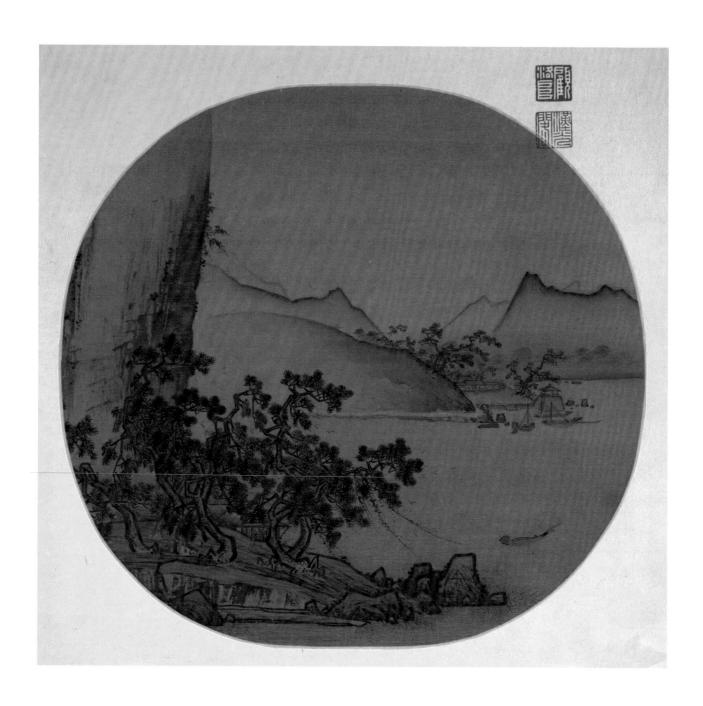

UNIDENTIFIED ARTIST
(formerly attributed to Yan Ciyu)
Boats Moored in the Wind and Rain
China, Southern Song dynasty (1127–1279)
Fan mounted as an album leaf; ink and color on silk
9¾ x 10¾ in.
The Metropolitan Museum of Art, New York
Image Copyright © The Metropolitan Museum of Art.
Image source: Art Resource, NY

Delight in Drizzle

October 16, 1984

One of my newer joys in living is the discovery that I can take delight in drizzle.

The incredible brightness of rain was brought home to me one recent day when I sat inside, staring out at a perfectly ordinary dull slate roof that suddenly appeared transformed. It not only glistened, it shone and it sparkled. Like lively patent leather.

On another recent day, I was enjoying, in a sort of mundane fashion, the usual features of a Chinese garden—rocks, water, plants—when suddenly, as out of nowhere, came a shower. In an instant, the garden came to life. Pools were animated with concentric circles. White plum blossoms snowed down upon a seated Buddha. And some great sonorous *chung* (bell) sounded an occasional moment with a profound knell.

And there have been other moments in the rain, perhaps inspired by some small awareness of the Chinese with their broad appreciation of nature, which have afforded me a start of surprise coupled with a chill-thrill of discovery. They include the wet sparkling sheen on a leaf or a flower, the drip-drop musicality of the falling water, the warm, cozy inwardness, homeboundness, and concentration potential of the rain.

Rain, in all of its variable intensities, has enhanced the history of Chinese landscape painting for centuries.

Stylistic subtleties seem to characterize the earlier examples. A Sung-dynasty (1127–1279) example from the John M. Crawford collection, *Boats Moored in Wind and Rain* by Yen Ts'u-yu, shows the rain indicated only by a couple of light, indeterminate lines. A Ming-dynasty (1368–1644) example from the C. Douglas Dillon collection, *Torrents of Driving and Flying Rain*, indicates the fact of rain only by a couple of individuals who are carrying umbrellas.

But, moving into modern times, Chinese paintings of the rain take on far more drama and strength, far more impressionism and expressionism. Today's Li Keran of Peking, dean of contemporary Chinese landscape artists, has a *Rain on the River Li (Kweilin)* with a remarkably effective and chilly blue-gray wash. And Huang Hsiang-chien of the Ch'ing dynasty (1644–1912), one of whose "travel recollections" from the Metropolitan Museum of Art can be seen on this page, shows a torrential storm.

The sheets of rain from a dark and moody sky fall on hills, streams, trees, clouds, home, and man to create a wet and wonderful version of a cosmic universe. The deftly structured work has a repetitive left-right axis, with blowing trees echoing the energies of the storm, and the erect outlines of a small abode serving as a foil to rain and trees. Huang's travel recollections invite us to interject ourselves, to play the armchair traveler, to move into the landscape, and to review our own summer rainstorms. We become the little fellow alone before our own front door in the rain; the house becomes our house; and the sheets of rain our sheets of rain.

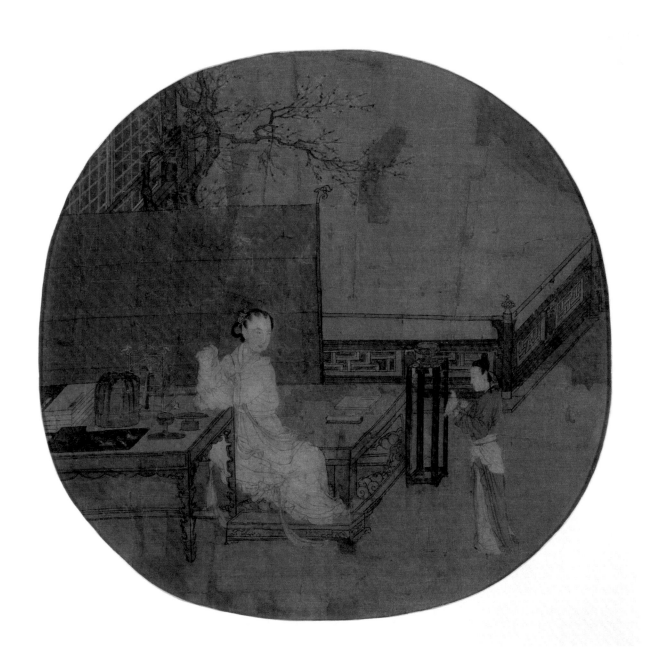

UNIDENTIFIED ARTIST
(formerly attributed to Wang Juzheng)
Lady Watching a Maid with a Parrot
Chinese, Southern Song dynasty (1127–1279)
Ink and color on silk
9³⁄₁₆ x 9½ in.
Museum of Fine Arts, Boston, Harriet Otis Cruft
Fund (37.302)
Photograph © 2016 Museum of Fine Arts, Boston

More than a Frill

June 24, 1981

The Chinese are in love with latticework, and in its designs we find another illustration of the complementary nature of the opposites.

Recently in China, I was charmed with the many examples I found of latticework—around doorways, in windows, and on fences. And I relished its use, almost universally, around the garden.

It is fascinating to conjecture that today, in China, eight hundred million people are rediscovering their gardens with their latticework ornamentation, rediscovering the ancient symbolisms of their views of "mountain-water," rediscovering the fact that the very vehicle for viewing, frequently latticework, also is symbolic.

Were I to take one feature from the accompanying picture which is to me of special intrigue, that feature would be the fence. I do not mean the fence of boards, which is immediately to the rear of the reclining woman. I mean, rather, the fence or balustrade that rides the right-hand corner of the painting.

This balustrade is distinguished by latticework in a certain geometric pattern, which recurs throughout the arts of China. It is often called

the "cloud and thunder motif," and it is equally often referred to as the "swastika fret." We encounter it commonly in bronzes, carpets, jades, and porcelains. It is less familiarly encountered in the field of painting.

Not only is the design remarkably "modern" in its angularity, its significance goes beyond design—as indeed do all the arts of China—to incorporate a symbolism. In Chinese art-iconography, the "cloud and thunder motif," or the "swastika fret," symbolizes immortality.

But the tight arithmetic angularity of the balustrade design contains yet another symbolic association, and one of an even higher calling. Indeed, it is its unique organic tension— the contrast of its closedness and its openness—that lends it both its drama and its philosophic verity based on an embrace of the opposites.

It seems to me that the two symbolic attitudes of the design are not at all in conflict. They are, rather, ultimately compatible. What partakes more of "immortality" than the

ancient concept of the yin and yang?

Chinese latticework occurs in any one of countless variations. It is always stylized and formal. Shapes can be square or round or a combination of the two. The square—such as the one we are dealing with here—takes its origin from the *tu*, or rectangular symbol for earth, whereas the round version has as its inspiration the *pi*, or rotund symbol for heaven.

Today, Chinese latticework has gone beyond the range of Chinese art and Chinese adaptations. To my surprise, I stumbled on a typical example of it—a window through which one viewed bamboo—in a decorating shop in San Francisco's Jackson Square. It made me realize that Chinese latticework has come into the public domain, and is now available to beauty seekers on a global basis.

Indisputably, Chinese latticework is marvelously decorative. But it is more than that. It can decorate our hearts, as well as our homes, with its instant reminder of the dynamics of contrasts into which all of life resolves.

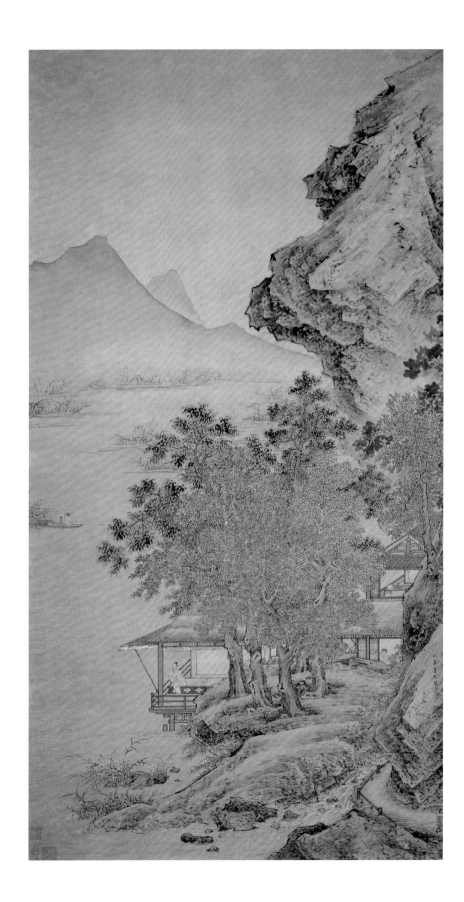

QIU YING
Fisherman's Flute Heard over the Lake
China, Ming dynasty (1368–1644)
Hanging scroll; ink and light color on paper
62⅛ x 33⅛ in.
The Nelson-Atkins Museum of Art, Kansas City,, Missouri, Gift of John M. Crawford Jr., in honor of the Fiftieth Anniversary of the Nelson-Atkins Museum of Art (F82-34)

Agreement through Contrast

January 11, 1982

Fisherman's Flute Heard over the Lake *insinuates music into landscape painting in a provocative blending of two arts.*

When the Chinese think of "fishermen," they think of the famous "Fisherman's Song," known and well loved since childhood. The song is always accompanied by the flute and is an ancient Taoist classic. Essentially slow, moody, and evocative, it includes dramatic contrast, both in tone and in pace, as does all Chinese music.

The "Fisherman's Song" describes the mountains and the water, contrasts which are also basic to Chinese landscape painting. It describes the "mountain-water" complex as scholars' meeting place. It comments on fishing in the lake within view of a commanding mountain. It projects in music what Taoism and the mountain-water theory convey in Chinese landscape painting. (And, it may well have been the inspiration for the Ch'iu Ying painting.)

When the Chinese think of "fisherman," they think also of their historic and philosophic concept of fisherman. The fisherman, to the Chinese, is not merely a man out to catch fish. He is not an intellectual mediocrity; he is a profound scholar, deeply committed to poetry and philosophy, and to the Taoist concept of contrast—as is the Chinese landscape artist.

And, finally, when the Chinese think of "fisherman," they think also of the flute, which is the accompaniment to his eternal song. Made of bamboo, the Chinese flute presents one of the major symbols of Chinese literature, with its admonition of resiliency—bend like the bamboo with the winds of life and do not break.

The fisherman and his flute take their place quite naturally in the painting by Ch'iu Ying (1494–1552), which very much duplicates the content of the song. The entire painting is full of contrast. We start with the overall composition, which is that of a *shan-shui* or "mountain-water" painting. We observe the strong delineation of the mountain in the foreground, together with the shadowed contour of its consort to the rear. We observe the fisherman, almost obscured by surrounding clumps of bamboo, in his open craft, and we note an audience of one in the foreground, sheltered by the overhanging roof of his gazebo.

This scene is a composition of diverse elements and finds its echo in the music, which lilts over the lake. The scene, which the scholar overlooks from his gazebo, finds its parallel in the fisherman-scholar's world of sound—now soft, now strong, now high, now low. It is as though the sound of music underscores the scene.

I think that the Chinese arts of music and of landscape painting are rooted in the same ancient Taoist theories of nature and the complementary character of the opposites. They stem from the same source. The two scholars in the painting—one in the gazebo, the other in his boat—are both enjoying and praising the natural world, the former in the visual sense, the latter in the aural.

The two figures further coexist as illustrative of the Chinese penchant for pairs. One is performing; the other is appreciating. They applaud each other. But, though dynamically interrelated, it is the fisherman, more than the other scholar, who becomes the important figure in the painting and the one from whom the work derives its title. Without the fisherman, the picture would be another Chinese landscape painting. With it, it becomes an extraordinary work of art.

But it is not only the two scholars who combine to make a pair. It is also the two arts that are a pair. *Fisherman's Flute Heard over the Lake* blends the art of music with the art of painting; and the two arts flower, even more fruitfully, in tandem.

Relief with design of dragons
China, Ming dynasty (1368–1644)
Marble
50½ x 90 x 4½ in.
Dayton Art Institute, Gift of Mrs. Harrie G. Carnell

Emperors and Friendly Dragons

September 9, 1975

Dragons, sources of fear and chills to the Western world, are sources of merriment and joy to the Chinese art lover.

Today, as never before, I am attracted to the dragons in Chinese art, dragons climbing upward toward the rim of porcelain coupes and vases, ornamenting the lustrous sheen of ancient fabrics, snaking across porous jades, peering out whimsically from countless paintings, and strutting extravagantly across historic tiles.

I have a miniature white jade coupe, or rounded bowl, perhaps only two inches in diameter. Its little handles are a pair of rounded dragons, which cheerily eye one another across the top. To me, they symbolize an upward movement of the dragon, which has come to be, since olden times, an integral part of Chinese lore.

The Chinese dragons are happy dragons. Their eyes squint with a gleeful glitter. They are at all times appealing and approachable—friendly, warm, and personable. It is as if they know that their omen is a good one (as it has been since time immemorial), and they are still bent on bringing joy to the world.

Sometimes the dragons give me a sense of wit and exhilaration when their bewhiskered little faces light up like a favorite old cat's. Sometimes they give me a more profound and symbolic sense of the deep joy to be found in the upward spiraling in the activities of life. And then there are even times when I think that the delight I find in dragons may be akin to royal entertainment—a sort of contemporary throwback to olden times when even emperors approached the dragon with love and admiration.

It was not only in affection that the ancient emperors held the dragon. It was something more like reverence. For the ancient emperors believed that the dragon represented all power, the power even of life itself, and consequently, all good. In accordance with ancient Chinese legend, it was the dragon who, wintering in the seas and summering in the skies, brought forth the rains that grew the crops of China.

In an effort to identify with this mythological marvel and share in his extraordinary powers, the emperors adorned themselves in silk and satin robes on which were emblazoned in radiant embroideries the imperial five-clawed dragon. They had their artists and their craftsmen perpetuate the concept of the dragon as a symbol of both power and upward movement. And after the dragon they named their most spectacular caves of sculpture Lungmen, or "Dragon Gate."

Today, we can all be emperors if we want, and adopt for ourselves the famous Chinese dragon. He will variously amuse us, divert us, and inspire us. And through the charm of his irresistible sinuosity, he will make his way into our hearts and fill them with seeds of joy.

頂乳新有此在隔付 趙男 兜之記

QI BASHI, HUANG BINHONG, AND FRIENDS
Presentation Album 1938–1940
China
Ink and color on paper
12 x 7¼ x 1¾ in. (album), 12 x 13⅞ in. (each painting)
The Mary M. Tanenbaum '36 Collection
Courtesy the Iris & B. Gerald Cantor Center for
Visual Arts at Stanford University

Nature-Clad Memories

October 31, 1979

Nostalgia dominates much of Chinese poetry and lends a special charm to the reading of it, even in translation. It often has to do with love or with life or with nature.

For example, Wang Wei (699–759), one of the greatest poet-artists of Chinese history, wrote:

> You have come from my native village?
> You surely have news for me!
> Does the sun still peep in my window?
> Are there buds on the old plum tree?

It seems to me that the sense of nostalgia, as evidenced in Chinese thought, is of a different character than the nostalgia to which we are most prone in our Western world.

Most of us, when we look back "nostalgically" upon our past look back on ourselves when we were young, or on homes, towns, friends, or possessions.

Rarely do we look back on nature. Rarely if ever do we look back on flowers. When most of us look back—say, to a former abode, as does Wang Wei—we look back to rooms, to architecture. Rarely would we conjure up a seasonal plant.

I feel that this Chinese preoccupation with nature, with growing things and sun and moon and sand and stars, as expressed in Chinese poetry, is quite in line with the Chinese principle of assuming that nature is the principal thread running through all Chinese thought and Chinese art.

If we try to think back to nature in our nostalgic moments, perhaps we will be linking our thoughts with the enduring rather than with the transient. It seems to me most likely that plum blossoms will outlast architecture.

When I think back to my early years in San Francisco, I remember schools, homes, friends, parents, teachers, but I also remember, with great comfort and reassurance, the great vistas of the bay that surround the city.

Chinese nostalgic poetry conjures up a host of idyllic scenes. Wang Wei's poem immediately sets up a vision, a picture or a painting, if you will. (One of his great contemporaries, Su Tung-p'o, said that Wang Wei's poetry was like painting and his painting like poetry.) As we read the words, we visualize the older man looking back with warming wonder at the sunshine and the flowering buds of his early home. We feel an undercurrent of melancholia or nostalgia, but in the main, the mood is a happy one, infused with longing. It is not gloomy, as our Western reminiscences often tend to be.

Is it perhaps serene and content because it is clothed in nature, rather than inanimate materiality?

二史臨流眼觀奇隉
風挹露正當時青春
景物有如此何象遊人
不費詩 沈周

SHEN ZHOU
Album of Twelve Landscape Paintings
China, ca. 1500
Ink and color on paper
12¾ x 23 in.
The Mary M. Tanenbaum '36 Collection (2004.131)
Courtesy the Iris & B. Gerald Cantor Center for Visual
Arts at Stanford University

Realism in Chinese Art

November 2, 1983

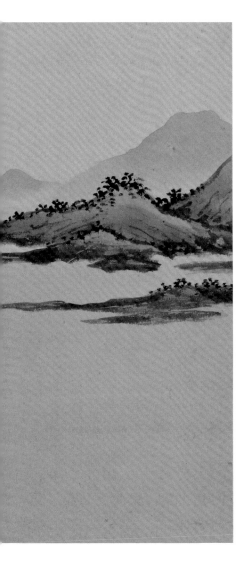

The return to realism, which today sweeps the Western world as an approach to art, reminds me of the unswerving dedication to realism on the part of countless Chinese landscape artists over countless centuries.

The Chinese landscape artist has never left "realism." From the T'ang dynasty (618–906), when the landscape painting had its beginnings at the hands of the revered Ku K'ai-chih, to the present time, Chinese landscape painting has been realistic.

It has varied, from stark and vertical, in the Northern Sung dynasty (960–1127), as reflective of the mountain regions of north China, to the gentler and more intimate studies of Southern Sung (1127–1279), which were reflective of the softer and less dramatic landscape of the south. Subsequent years, through the Ming and Ch'ing dynasties, and even to the present time, have witnessed endless variations on the ancient themes.

I think the reason the Chinese landscape artist has stayed so close to nature is the fact that the totality of his psyche, of his inherited tradition, has been nature dominated, nature directed, and nature involved. His landscape painting became the showcase of his conviction, the visual translation of the philosophic teachings of Lao-tzu, Confucius, and the Buddha—all of whom exult in nature and point up its relationship with humanity.

Also, the name for landscape painting in Chinese is *shan-shui*, which means "mountain-water." And mountain-water, which is as close to nature as one can get, not only supports realism, but also represents the yang and yin, or strong and weak, an ancient theory of oppositional interplay through which individuals can view themselves afresh.

At Kweilin in southern China, I picked up a couple of contemporary Chinese landscape paintings. They incorporate the tradition of mountain-water. They are traditional, and yet they also incorporate certain modern details in color, which give them an aura of the twentieth century, rather than seeming a replay of ancient times.

Kweilin has been for centuries a famous Chinese art center of rare charm, with uniquely shaped extraordinary mountains reflecting in the slow, meandering waters of the River Li. In Kweilin, mountain-water painting (or *shan-shui*) comes dramatically to life.

A major New York art critic has discussed the moral tone as of radical importance in the world of painting. Could there be any greater moral tone than that which energizes Chinese landscape painting, than that which—through realism—conveys to the onlooker an expanded comprehension of human life itself?

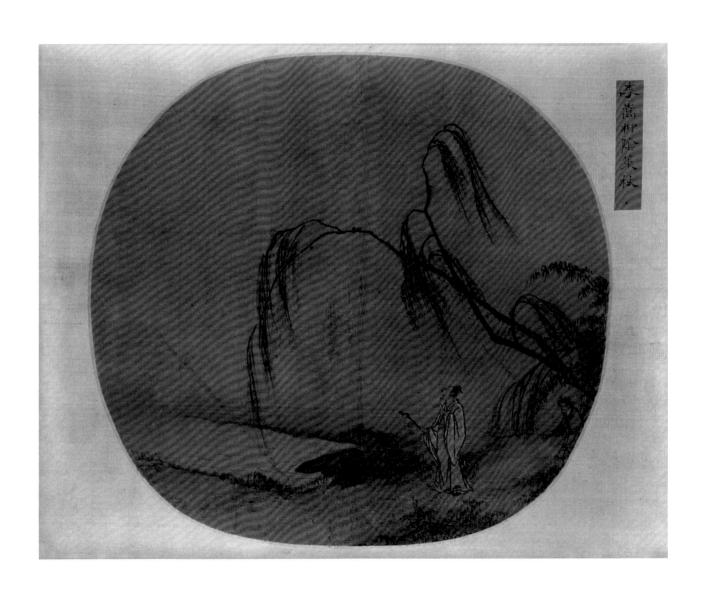

TRADITIONALLY ATTRIBUTED TO LI SONG (LI SUNG)
Sage and Attendant beneath a Willow
China, Southern Song dynasty (1127–1279)
Circular fan mounted as an album leaf; ink and slight
color on silk
9⁵⁄₁₆ x 10 in.
Harvard Art Museums/Arthur M. Sackler Museum,
Gift of Dr. Denman W. Ross (1924.20)
Photo: Imaging Department © President and Fellows
of Harvard College

So Much the Branches Tell

June 23, 1980

In China, the willow is the symbol of spring, and of femininity. It is also the Buddhist symbol of meekness.

I am reminded of how, spring after spring, I thrill to the first sight of the willow. There is something about the chartreuse yellow of its coloring which bespeaks spring. New life. New hope. Freshness. It is a color unparalleled in nature at any other time of year, and just to look upon it is a tonic for the spirit.

It is not only the coloring of the willow which startles and delights when first sighted in the spring, it is also the great arcs of its swerving branches—its design. From the points of view of both design and color, the willow becomes a magnet, as well as a symbol of the season, while implications of its fragility and its transience ingratiate with the viewer even further.

On a recent trip to China, I noticed willows around the West Lake of Hangchou, where the great artists of the Southern Sung (1127–1279) conceived their paintings. It was winter, but I could imagine their loveliness in spring, with nature lovers strolling under them like sages.

In the accompanying painting from the Southern Sung, *Sage and Attendant beneath a Willow*, the sage seems to be delighting in the first blush of the willow's annual appearance. Lightly clad in spring array, he strolls beneath its bending branches, which seem wand like in evanescence as they envelop him.

Why is he a wise man, a sage, who strolls beneath the willow tree? I think he is a wise man because he defers to and highly regards the light, airy, almost ethereal color and conformation of the willow. And further, I think he is a sage because he glories in the environment of nature; and, in so doing, he joins the philosophically elite. He is acting out the fifth-century B.C. directive of the Buddha, who urged man to return to nature to find peace.

It is the ineffable delicacy of the conformation of the willow which leads to the Chinese interpretation of the willow as the Buddhist symbol of meekness, for, of all the trees, it is the willow that is the most gentle. The most unprepossessing. The most meek.

In the attitude toward the willow, I think of the similarities between two cultures, American and Chinese. Not only is the springtime symbolism a feeling that both share, both also share in its symbolism of femininity. How common, for example, is the description of a girl's "willowy" waist, a metaphor that is again proverbial in China.

Why should it be called the "weeping" willow, I wonder, when it is to many a source of joy? Exploring the subject, I find that "weeping" can mean bending and refer to the physical posture of the falling branches.

But, then, I wonder if the willow might not also be emotionally weeping—sorrowful over a segment of straying humanity, just as the Buddha was, so very long ago?

The Beauty of One Line

March 11, 1976

What is there, I wonder, about the Chinese curving rooftop that gives it such utter fascination?

On a very elementary level, it speaks to me through its design. Its design consists of one line only—stark, ornamented, unadorned. It is a line as "abstract" as in so-called modern architecture. And, because I am a modern creature, the Chinese curving rooftop impresses me as familiar, engaging, and of my time.

Although the Chinese curving rooftop so much resembles modern architecture, it goes far beyond it in its subtle refinements of design. No mere simplistic and straight line, it tends to bear down in the center; and it tends also to spring up at either end. It is a complex presentation of one line; and yet, whether done in art or architecture, it has a lightness and fluidity that any modern artist or architect could well envy.

Not only does the apparent simplicity of the line of the curving rooftop engage me and hold my interest, it also appeals to me by virtue of its color. In the moody gray and open landscape paintings, which are so strong a feature of Chinese art, the rooftop is often an abbreviated linear dash, giving the entire composition its depth and its completeness. On the other hand, in Chinese architecture, colored tiles enliven the extravagant flaring rooftops with yellows and with golds that glisten in the sun and in the rain.

Still another aesthetic consideration forces itself upon me, as I contemplate with wonder the almost hypnotic effect of the Chinese curving rooftop. And that is the observation that when it occurs, either in art or in architecture, apart from being dynamic in itself, it often presents a charming contrast to surrounding trees and foliage. It is a satisfying horizontal complement to the verticality of trees, a neat deft complement to the informality of the foliage.

And finally I think that, in addition to the obvious artistic attraction of the curving rooftop—in design, color, and association—there is still another, a more philosophic, source of its intrigue. I find implied in its upward-downwardness that "yang and yin," or positive-negative duality, which so much underwrites all Chinese life and thought.

A sixth-century introduction into Chinese architecture, the curving rooftop immediately became the most striking feature of that architecture, although it has ever since baffled art historians in their efforts to ferret out its origins and its functions. Regardless of whether it was simultaneously a shelter from the rain and a filter for the sun, whether it was influenced by curvilinear designs of calligraphy or of nature, whether it came from southeast Asia or bore some resemblance to earlier times and life in tents, the Chinese curving rooftop has continued down through the ages as a major motif both in Chinese architecture and in Chinese art.

Incorporating one of the most ancient of philosophies, it is available to all of us today in illustrations, in "the museum without walls." It is a dramatic example of the power of a line to convey both philosophy and design, and to provoke insight as well as pleasure.

DONG QICHANG (1555–1636)
Landscapes
China, Ming dynasty (1368–1644)
Album of eight paintings and one artist's colophon, leaf D; ink on paper
9⅝ x 6⁵⁄₁₆ in.
The Metropolitan Museum of Art, New York, Edward Elliott Family Collection, Gift of Douglas Dillon, 1986 (1986.266.5a-k) Image copyright © The Metropolitan Museum of Art. Image source: Art Resource, NY

THE PLACES
IN BETWEEN

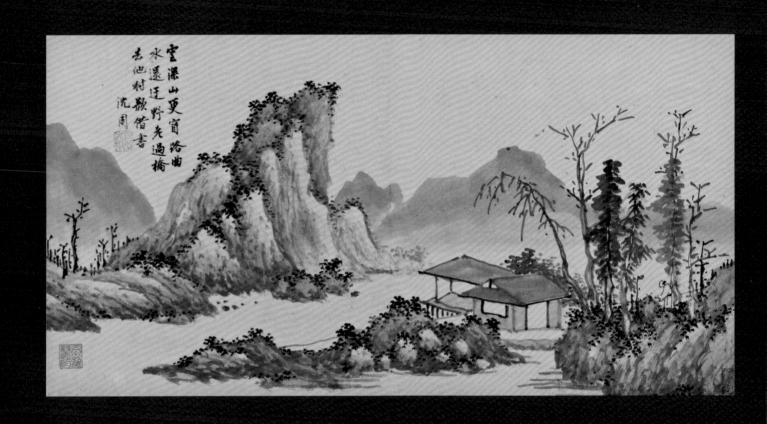

Reading the Chinese Landscape Painting

According to the memorable saying of Tsung Ping, artist and critic of the fifth century, "A well-executed painting can take the place of nature; no need to walk on precipitous cliffs."

The art of Chinese landscape painting developed gradually, in both composition and technique, during T'ang times (A.D. 618–906), until it reached its efflorescence in the Sung dynasty (A.D. 960–1279). The formula of a solitary, miniscule man counterpoised against an immensity of landscape, which was adhered to by successive generations and successive dynasties—Yuan, Ming, and Ch'ing—was already firmly established in Sung times. Much of what came later is, in a sense, a variation on a theme. Landscape paintings of the Sung dynasty, with the dwarfed human figure providing scale to the composition, break down into Northern Sung and Southern Sung. The former are of powerful mountainous verticality, and the latter of a more homey and delicate intimacy, with man positioned at or on a lake, rather than poised in alpine mountains.

Quite different from our Western art of landscape, which can depict a hill or a plain, the Chinese approach to landscape painting invariably involves water and mountains. Because of this dual focus, the Chinese have coined the term *shan-shui*, which means "mountain-water"

painting. The "water" and the "mountain" need not be expansive or extensive. The water may be the trickle of a stream, and the mountain may be a tapering off into a shallow hill at water's edge, but they are invariably there, incorporated into the general concept of the landscape.

My own fascination with Chinese landscape painting arose from a direct encounter with the traditions and tools of the art while on a visit to the Weng family outside New York City, where I was then living. But before that pivotal evening at the Wengs', I had already had an experience that left me wide open to the appreciation of Chinese landscape. One day J. B. Neumann, in whose gallery I was working and who had come to be my mentor in the field of Western art, asked me to accompany him to an opening at the Museum of Modern Art. I did so, and the opening turned out to be for an exhibit of works by Piet Mondrian. I believe this was the first time I had seen "nonobjective" art, which would not only come to dominate the New York art scene, but also transform that scene into an international guiding light with its so-called (and short-lived) New York School.

I shall never forget how, in complete bewilderment, I stood rooted to a spot and looked back and forth from one of the paintings—which said nothing to me, composed as it was of black and red and white geometric patterning—to

my old friend J. B., who kept waving his arms and exclaiming with wild enthusiasm, "This is it, this is art!" I felt not just that J. B. was letting me down, but that my own country had let me down, in accepting as valid art this nonsense.

My concept of art was derived from my classes at Stanford University, where in the whole gamut of mankind's expressive creativity, including painting as well as literature, "art" by such disparate figures as Diego Rivera and Émile Zola was construed as "nature seen through a temperament" and a "slice of life."

As nonobjective art began to flood the New York market, I lost my enthusiasm for visiting galleries. I felt that I was wasting my time in looking at this poseur, this pastiche of art. Always having been an art lover, I was ripe for something new; what came along as new to me was Chinese painting, old though it was. It was to be in Chinese art that I would find satisfied my need for nature in all its forms, and in a variety I could never have known possible.

Chinese landscape painting is not only different from today's accepted norms for painting. It is different from any art that we have known in the West at any time, although some have occasionally suggested coincidental parallels, such as in the abstractions of Paul Klee or in the landscapes of Corot and Vlaminck.

The differences assert themselves in the subject matter, but also in color and design, and in materials and technique. They assert themselves further in matters of intention: whereas the Western artist appears to exploit himself and his subconscious, the Chinese artist propagandizes his inherited convictions about man in relation to the world, so that his art becomes of philosophic import as well as mere decor.

"Abstract" is a word glibly bandied about these days in Western art; to me, in the modern Western sense, it means nothing more than nothingness. The Chinese artist, on the other hand, has always used abstraction, or simplification, both in his brush technique and in his overall conceptualization. He simplifies in order to dramatize the effect that he desires. I remember that my first feeling for these Chinese paintings, on that evening at the Wengs', resulted from the irresistibility of the figure of that "little man," created by a few deft lines.

Line is the cardinal tool of abstraction in Chinese painting; it has been so ever since the days of Ku K'ai-chih, an inventor of the genre, in the fourth century.

The materials used in Chinese painting differ radically from anything we know in Western art. We have no parallel to the ink-stick, ink-stone, or Chinese paper, which together with the brush, make up what is known

to the Chinese as the "Four Treasures." All of these objects are collector's items, and they are often artworks in themselves. They all came into being in Han times (206 B.C.–A.D. 220). They all enjoyed the patronage of emperors. They all developed, as did the painting itself, through utilizing the achievements of the ancestors.

Brushes, on long slender handles of bamboo, are apt to be of either rabbit or sheep hair, although Wango Weng's brushes, the first I saw, happened to be weasel. The sheep's-hair brush excels in bolder work, and the rabbit's-hair brush in the finer; the artist painting landscapes will generally employ first the sheep's-hair brush to describe the lines of a rushing torrent or the sweeping downward arc of an elongated mountainside. The rabbit's-hair brush was already in general usage in Han times; it was the T'ang artist, Liu Kung-ch'uan, who evolved the sheep's-hair brush, which immediately became popular and has since been in general vogue.

I have a friend who tells me that her mother, in Shanghai, practices her brushstrokes every day, as part of her regimen or lifestyle. Brushstroke practice has been and is an ancient custom for many Chinese people. It is supposed to be an exercise and a tonic for the system. The practitioners believe that it keeps them in touch with all nature and with the ancestors, and that it keeps them in good physical and mental health. Brushstroke practice is considered a form of both physical and psychic therapy.

The next "treasure" of the artist's table, ink, as we observed it that evening at the Wengs', is not originally liquid, as is usual today. It is a solid, narrow, longish block or stick, which, when rubbed with water against its companion piece, the ink-stone, liquefies into something like the ink we know. It is into this freshly made concoction that the Chinese artist dips his brush. Wango Weng's ink-stick was black. As he took it in his hand, I noticed that it was engraved with a chic contrasting motif in shining gold.

The modern process of making the Chinese ink-stick is the same as in ancient times, the recipe consisting of ten parts pine-smoke deposit, or soot, to five parts gum. After being mixed and shaped, the sticks are put into a temperate place to harden. As with the brushes, the artist's choice of ink varies, according to the task at hand. The pine-smoke variety yield a deep black liquid, ideal for the painting of pine needles; whereas an oil-smoke ink is not so black, creates a glossy surface, and is considered ideal for rainy, windy scenery.

Alter ego to the ink-stick, the ink-stone is the flat receptacle on which the ink is ground and mixed with water. We watched that evening as Wango gave a little

demonstration, painting a small landscape, with a small man at the water's edge, very rapidly and very easily. I noticed that his black ink-stone had the same lively gold motif as did his ink-stick.

The T'ang emperor Tsuan Tsung was himself a dabbler in painting and liked to make his own ink-stones in original designs. He called them "dragon-scale moon-crescents." In presenting his crescent-fashioned ink-stones to each of his prime ministers, Tsuan Tsung set a precedent for elevating ink-stones to the highest caliber. In subsequent dynasties, special officers were appointed for the making of ink-stones, one of whom, Li Shao-wei, designed them as "dragon tails."

The characteristic Chinese paper is coarse in weave and more porous than our paper in the West. It is especially suited to the Chinese artist's lively manner of handling the brush. Wango's preference is rice paper, and, despite its name, it comes from the mulberry bush. The materials used for making Chinese papers depend on the providence of nature in the various provinces. Hemp has been the choice in Ssu-ch'uan; bamboo in Chekiang, Kiangsu, and Kiangsi; the water fungus in the coastal towns; and mulberry in the north. Regardless of their points of origin, the papers share, with the other "treasures" as well as with their products, a strong underlying nature-orientation basic to the Chinese arts. An abiding awareness of nature has influenced their nomenclature. T'ang papers were "blue cloud" and "white jade"; a tenth-century paper was "purify heart hall"; and a Ming paper was called "weaver of bamboo blind."

At Wango's invitation, I tried to use the treasures. My attempt was a fiasco. I tried to sit up straight, as I was told; to hold the brush perpendicular to the paper; to create a lively landscape from my mind. And it was a disaster. I came to understand that the seeming simplicity of Chinese painting was illusion; that nothing could be more demanding of the artist than this apparently guileless ease. Nothing could necessitate more self-discipline, more rigorous control, than these charming landscapes, which give the erroneous impression of effortlessness.

I never thought, as that wondrous evening at the Wengs' in Westchester drew to a close, that I would ever, myself, own a Chinese landscape painting. For the moment, I had a new view on myself, as a dwarfed little dot, and the world. And that, for the time, was enough.

For years I kept this new passion for Chinese landscape painting to myself, fearful that if I mentioned to anyone that a picture brought me back to San Francisco—a place whose ch'i, or energy, I loved— I might be suspected as delusionary. I felt my positive reaction validated long later, when I came across Tsung Ping's quotation.

Now, finally on firm ground, I could not only talk about Chinese landscape painting, I could also write about it.

I have always written, since my days with the San Francisco Chronicle, for periodicals and newspapers— including the New York Times and the New York International Herald Tribune—on travel, fashion, and personalities. It was my father who used to say to me, early on in San Francisco, "Do something with your writing. Why don't you specialize in Chinese? This is a day of specialization, and you are always down in Chinatown."

Shortly thereafter, I picked up a copy of Writer's Digest and noticed that the Christian Science Monitor was looking for essays. The essay, I thought with interest, would give me the opportunity to write in the first person for a change, instead of with my accustomed objectivity. As the Digest suggested, I sent a query letter to the editor, asking if they would consider essays on Chinese culture. I have been contributing articles to the Christian Science Monitor ever since.

Today my Chinese life proliferates, like a California poppy spreading across a landscape, into a multifaceted, yet consistent, complex. It includes love affairs with Chinese artistic, philosophic, and symbolic thought; with all of the arts, now including music; with the garden, food, and friends. And all these fields conjoin beneath the same umbrella.

In San Francisco I am still magnetized and mesmerized by the bay, the ocean, and by Chinatown. On every trip to the city, I happily and humbly survey them all. But today, my visits to the bay, the ocean, and Chinatown are enriched by a familiarity with Chinese culture.

I see in all of them the positives and negatives of Chinese thought, and further, I now see myself as a small but inseparable particle of "the view," be it the crashing waves that still embrace Land's End or the bridges that circumvent the bay. Chinatown is still for me the jazzy thrill of yesterday—but now it is even more. There are profound meanings now, expressions of the dichotomy of "yin and yang," even in the upturned rooftops of the corner lantern posts.

I now see Chinese landscape painting—and especially the landscape handscroll, which I collect—as a central showcase of Chinese thought. It projects both the concept of man's identity with nature and the sense of contrasts, or dichotomy, that runs so pervasively through all of Chinese thought. It is literature at the same time that it is art.

那些位于中间的寂静地方
《基督教科学箴言报》 1975 年 5 月 21 日

多年前的一天，当我阅读一篇中国古典作品时，我被这句话震惊，许久说不出话来：
"只有在一无所有的地方，车子才有用。"

"真是不可思议，"我当时想。"这句话浓缩了整个中国文化！"

"...一无所有的地方。"我陷入了沉思，并在接下来的几年里不断地思索这十几个字的深刻含义，它们似乎将全部中国文化掌握了。

我想到山水画，想到这些作品的成功之处在很大程度上得益于对空白的利用，也就是那些"一无所有的地方"。我想到那些可爱的玉器、青铜器以及瓷器，它们的用处在"一无所有的地方"是多么明显。然后，我还想到中国建筑的空旷性，以及那一定程度上的简约是如何制作出一种情绪和氛围。

在那个如今已经成为著名而且不朽的章节，老子利用一系列简单的比喻来凸显其理论的无可争辩性。他提到了房屋，以及室内"一无所用"的空间是如何使得房屋有用。他提到了被用来制作容器的粘土，这种材料似乎是制作容器的关键，可事实上正是容器内部"一无所有"的空间的大小才决定了它的有用程度。他还提到车轮，讲述了为什么车轮的功效并不取决于它的辐辏，而是取决于车轮能够经过的一无所有的空间。

"...一无所有的地方。"当这句话第一次出现在生活在公元前 5 世纪也就是与孔子同时代的老子写的《道德经》中时，其意义可能与现在很不相同。它的本来意思，我觉得，也许是指向当时的读者的思维，指出他们需要清空自己思想中的非真实因素，再以真正有意义的内容取代之。老子深谙自然及其与生俱来的宁静，并觉得自己有义务帮助同时代的人摆脱对物质的欲求。

"...一无所有的地方。"如果我们能从精神上和身体上摆脱不可欲求的和不重要的，发现和平、宁静、美丽和健康，我们的生活和经验将会变得多么有意义。

Those Quiet Spaces In Between

May 21, 1975

One time, many years ago, while reading through an ancient Chinese classic, I stared in silent wonder at a handful of words which leaped out from the page. "The usefulness of the vessel depends upon *the place where there is nothing.*"

"Isn't this incredible," I thought. "It typifies the whole range of Chinese culture!"

"The place where there is nothing." I mused and mused, and I continue to do so, after several years, about the extraordinary reach of those half dozen words, which seem almost to hold Chinese culture in their grasp.

I think about the landscape paintings, and about how much of their effectiveness is due to the use of empty spaces, to "the place where there is nothing." I think about the lovely jade and bronze and porcelain vases, and about how pragmatic is the truth that their function is in "the place where there is nothing." And then I think of the sparse emptiness of Chinese houses, and of how a certain austerity creates a mood and an ambience.

In a now famous and immortal stanza, Lao-tzu conjures up a host of homely illustrations to point up the incontestable nature of his thesis. He talks about the house, and of how it is the "nothingness" of indoors and windows which gives the house its value. He talks about the clay, which appears to "make" the bowl, and of how its real capabilities exist in the vacuum created by it. And he talks about the wheel, and of how its performance rests not within its spokes but in the empty spaces in between them.

"The place where there is nothing." The words may have had a very different meaning when they first appeared in *The Way and Its Power* (the *Tao Te Ching*) of Lao-tzu, who is supposed to have lived, contemporary with Confucius, in the fifth century B.C. The original meaning may have, I think, referred to the mind of the reader and to the need of emptying it of untruths in order to replenish it with constructive substitutions. Lao-tzu, upholding as he did the virtues of nature with its concomitant serenity, felt a profound obligation to urge his contemporaries to rid themselves of material desires.

"The place where there is nothing." How much more effective will be our lives and our experiences, if we rid ourselves mentally and physically of the undesirable and unimportant, finding peace, serenity, beauty, and well-being.

"Those Quiet Spaces In Between"
translated into Chinese

Painting Is Poetry

April 14, 1976

"Poetry is painting, and painting is poetry," said Wang Wei (699–759), celebrated T'ang-dynasty poet-painter.

Looking around my garden, I meditate on the concurrence of poetry and painting, as suggested by Wang Wei so very long ago. And everywhere I look, it seems to me, is a vision conceivable in either form.

A bird lights upon a slender branch and draws in its wings in protest at the evening chill. A branch of bamboo bends over toward a stone pagoda, in seeming deference. An umbrella of a dogwood tree casts a protective shadow over a seated figure of the Buddha, his clasped hands safeguarding a small parcel of dried leaves, assembled from some winter past.

I think of the seeming coincidence of poetry and painting and of how it has been revealed by the Chinese. And I think of how this provocative coincidence is by no means restricted to my garden, but of how it actually embraces the entire out-of-doors. As I walk along the rivers, as I stare out to the sea, as I explore deserted roads and look high into their hills and deep into their valleys, I encounter countless spectacles, which are potential poems as well as paintings.

Struck by this intriguing phenomenon, I wonder how it came to be. And my answer, as so often happens when raising questions on Chinese culture, is nature. It is the same sense of nature—with its birds and its trees, its mountains and its rivers, its flora and its fauna—which looms so large in Chinese painting and enters, just as pervasively and profoundly, the poetry of China.

And then I realize that not only is the subject matter the same for both the Chinese painting and the Chinese poetry, but the mood also is in both very much the same—that is, a mood of calm reflection.

The Chinese emperor Hui-tsung (1101–1155), in the conduct of his Imperial Academy (Han Lin Hua Yuan), used a technique of correlating poetry and painting in order to develop a spirit of competition among his artists. He used to read poems to them, and then later awarded prizes to the ones who had been able most successfully to transcribe the poems into paintings. Poems delivered by Hui-tsung to his academy include, "Wild Waters Crossed, the Lonely Boat Lies Idle All the Day" and "Old Temple Hidden in Myriad Mountains."

Today, as in the times of Wang Wei and Hui-tsung, we can look upon the innumerable lovelinesses of nature. We can enjoy them, not only for what they are but also for what they can represent, both as poems and as paintings. And we can be thrice blessed with joy.

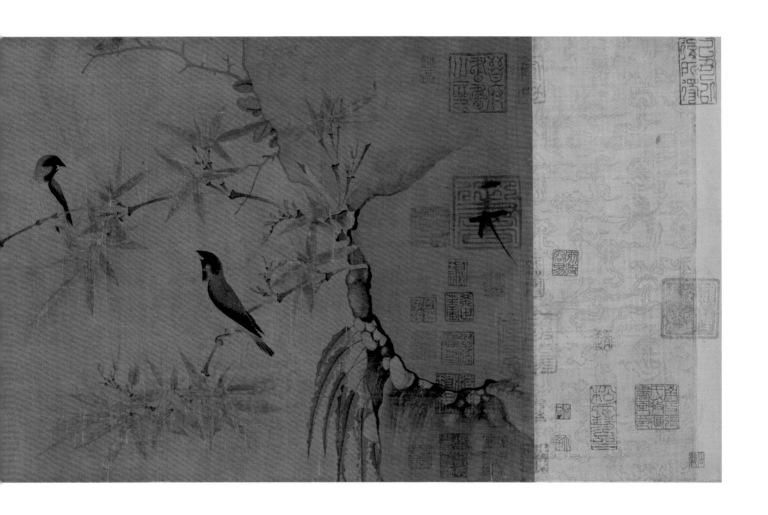

HUIZONG
Finches and Bamboo
China, Northern Song dynasty (960–1127)
Handscroll; ink and color on silk
Image: 13¼ x 21¹³⁄₁₆ in.; with mounting: 13¾ x 330⁵⁄₁₆ in.
The Metropolitan Museum of Art, New York, John M.
Crawford Jr. Collection, Purchase, Douglas Dillon Gift, 1981
(1981.278) Image copyright © The Metropolitan Museum
of Art. Image source: Art Resource, NY

A Winter Transformation

February 16, 1977

I look out on my garden, and the ground, which was dark, is now light with snow.

Trees are salt and pepper. The pools, which used to appear black from my window amphitheater, now are frosty white. The sculpted Buddha in the corner, which habitually appears a stony gray, now seems to warm himself in a lap robe of white fur. And the snow lantern (so-called because it looks most beautiful when beneath a crown of snow) now has on its tallest topknot for its fullest glory.

In this winter transformation it is easy to recognize the contrast that has been such grist to the Chinese artist's mill. Branches of the dogwood trees, heretofore a monotone of spindly convoluted blacks, now appear outlined in brilliant white, dazzling even in the darkness of a late winter afternoon. It is as though some master craftsman had applied his highlights of pure white paint with an even brush.

The bamboo, too, appears in a totally new guise. It droops and falls, down by the pool, almost like a little willow. Different from the dogwood branches—which do not lose their sharp attenuation, and on which the new white crest is constant down its length—the bamboo not only bends with the newly fallen snow, but also seems to shed the snow in bending.

It is perhaps because the snow imparts this quickening sense of

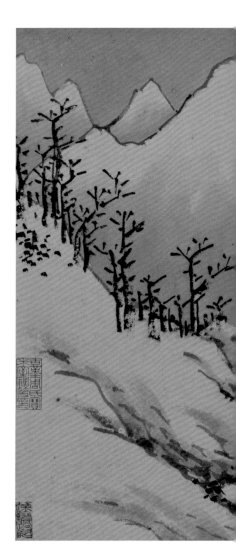

contrast that snow scenes have long been favorite subjects for Chinese artists. All the greatest landscapists—including Fan K'uan and Li Ch'eng of the Sung dynasty (960–1279) and Shen Chou and T'ang Yin of the Ming dynasty (1368–1644)—have reveled in the painting of a land turned white. And in their paintings, I see many of the same effects that I see out of my own window: not only the contrasts of light and dark, but also the fact that the generalized intrusion of the white dramatizes the darkness of uncovered patches like twigs and trunks and rocks and stones.

And then I think, suddenly and with great interest, of the probing approaches of the Chinese artist. He is not satisfied merely with a cursory observation of the contrast of light and dark. He finds in the sense of contrast, on a snowy day, another representation of his yin and yang, or complementary nature of opposites. His interpretation of this conviction comes to be the guiding spirit of his hand.

Ah, I wish that the transforming nature of the snow could cast its cleansing mantle also on other aspects of our contemporary world, and return them as well to this unspoiled loveliness which so much allured the Chinese artists of a thousand years ago.

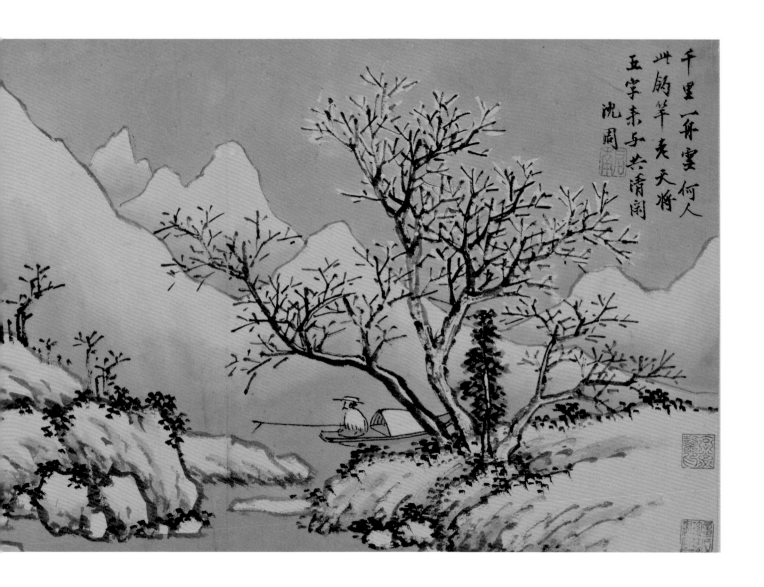

千里一扁舟何人
业釣竿共天將
五字来与共清閑
沈周

SHEN ZHOU
Album of Twelve Landscape Paintings
China, ca. 1500
Ink and color on paper
12¾ x 23 in.
The Mary M. Tanenbaum '36 Collection
(2004.131)
Courtesy the Iris & B. Gerald Cantor Center
for Visual Arts at Stanford University

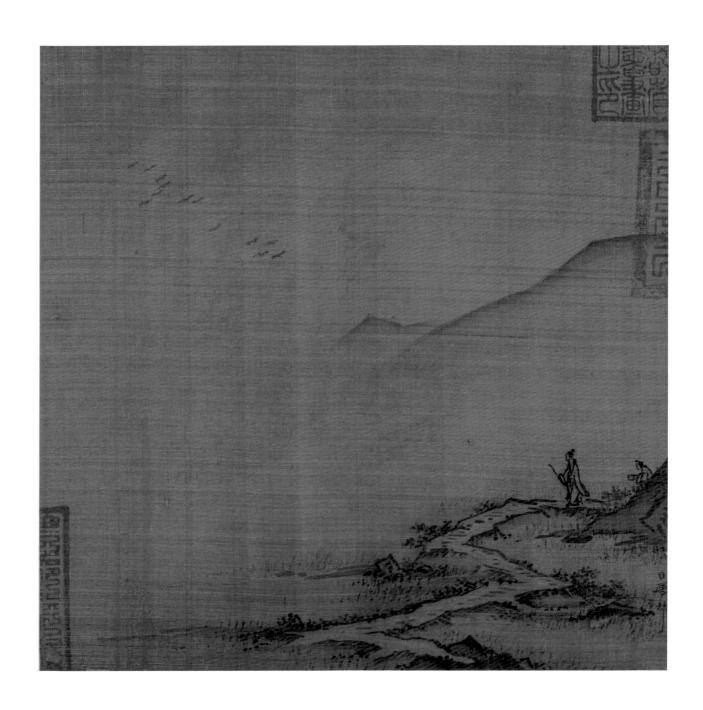

MA LIN
Landscape with Flying Geese
China, Southern Song dynasty (1127–1279)
Album leaf; ink and slight color on silk
10 x 10½ in.
The Cleveland Museum of Art,
John L. Severance Fund (1952.285)

Art Replacing Nature

August 13, 1974

Tsung Ping, a Chinese art critic of the fifth century, once said, "A well-executed painting will take the place of nature . . . No need to walk on precipitous cliffs."

Chinese landscape painting reached its heights in the Sung dynasty, which ran in China from 960 to 1279. An immediate success, it took the art world of the time by storm. It occurred in three formats: in the vertical "hanging scroll," in the horizontal "handscroll," and, finally, in the small and intimate "album leaf," which we picture here, on pages no larger than that of an average book.

Regardless of its format, Chinese landscape painting is above all else a rhapsody to nature. And there is something about it, as Tsung Ping noted, which is peculiarly seductive. It brings us right into the world it represents. It projects us to the seaside . . . to a spot beneath a pine tree . . . to a boat upon a lake . . . to a path in full view of a school of circling geese . . .

Briefly, Chinese landscape painting takes us, in the flicker of a glance, wherever we would most like to be. It is indeed a magic carpet. It is a vacation from the daily world. It is a vacation we can make in our own home, in our own time, in our own hands. And it is a vacation we can make winter or summer, regardless of the calendar, whenever we would like to escape to an ideal world.

It was a philosopher named Lao-tzu, who had been presumably a contemporary of Confucius in the fifth century B.C., whose thinking came to lay the groundwork, later in Sung times, for Chinese landscape painting. Lao-tzu, in a philosophy called Taoism, urged man to return to nature, and to forgo the greed and artifices of materialist society.

The type of Chinese landscape painting called the album leaf came into being in southern China during the reign of the emperor Hui-tsung (1101–1125). Chinese emperors of this long-ago time were themselves artists and calligraphers, and Hui-Tsung was no exception. He and his son, Kao-tsung, who was to inherit the domain, included landscape painting as part of civil service examinations, and by doing so, fostered competition and excellence among their artists. Right up there at the top of the Imperial Academy were such artists as Ma Lin.

The most important single element of Chinese landscape painting is the brushstroke. Chinese painting, done with brush and ink, more resembles what we call "watercolor" than what we call "painting." The brushstroke should be firm and free, and yet at the same time, it must be controlled.

For a thousand years, Chinese landscape painting has fascinated museum curators and art collectors around the world. And today, with the renewing interest of our Western world in Chinese art, it can fascinate us also. Not only fascinate. Even more, enrich.

We can contemplate a Chinese painting, and we can move into it, into a lovelier spot—now—just as Tsung Ping anticipated so many years ago.

The Art of Order

August 5, 1976

In a now revered and celebrated comment, Tung Ch'i-ch'ang, major Chinese landscape artist of the seventeenth century, once said that the picture is better than the place.

I have a little handscroll on my desk. It is only about five inches high. And when extended horizontally, the picture may be about a foot in length.

My scroll may be a "mini" scroll in size, but it is portentous and majestic in its implications for me. It brings me unfailingly to nature.

Snow may be upon the ground outside; rain may be teeming down in torrents; a foggy haze may be enveloping the actual out-of-doors.

But in my "mini" scroll all is sun and light; the climate and the ambiance are reliable, constant, and unchanging.

There are certain details on which I like especially to linger when I contemplate my handscroll. One is a great verticality of waterfall, a narrow ribbon between two yawning chasms. But another one, and the one to which I return most often, is the part which shows an infinitesimal little man, peering out of his lonely hut at the base of dizzying lofty mountains.

The striking figure of Tung Ch'i-ch'ang (1555–1636) dominated the Chinese art world of the late Ming dynasty. He was not only a painter but also a connoisseur, a collector, and a theorist. He was by far the most eminent authority on painting of his time. He undertook to codify painting styles and to bring the whole history and art of painting into a state of order, satisfactory to himself and convincing to his contemporaries. He succeeded so well in his endeavor that most

DONG QICHANG
River and Mountains on a Clear Autumn Day
China, c. 1624-1627
Handscroll; ink on Korean paper
15 x 53 ⁴/₅ in.
The Cleveland Museum of Art, Purchase
from the J.H. Wade Fund (1959.46)

books about painting written in China after his time refer to him as master.

In a major effort to free Chinese painting from flat conventionality and to revive its calligraphic base, Tung Ch'i-ch'ang extolled calligraphy and made his now historic observation that, to the lover of line and design, real landscape can never equal painting.

In his comment, preferring art to nature, Tung Ch'i-ch'ang went a step beyond his sixth-century predecessor, Tsung Ping, who had said that the painting could take the place of nature. After many years of enthusiastic enjoyment of both art and nature, I find that my own conclusion finally confirms that of Tung Ch'i-ch'ang. The indubitable vagaries of climate, which affect so radically the presentation of the actual out-of-doors, are successfully obviated in the painting; and the painting thus becomes my only sure access

to nature—more certain, even, than nature itself can be.

Am I not better served then, to have a painting as my window on the world—better, perhaps, than to have the actual world itself? A painting, which is oblivious to fog, to sleet, to rain, even to sun when too brilliant? A painting that can perform satisfactorily for me at all times, regardless of the weather?

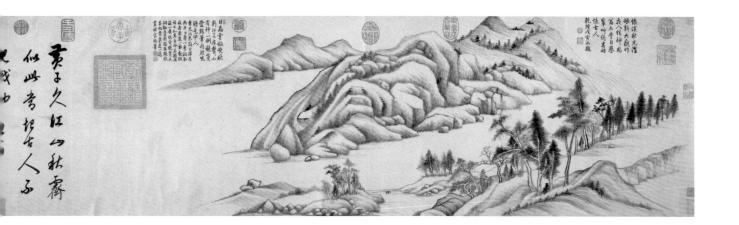

UNIDENTIFIED ARTIST
Narcissus
China, Southern Song dynasty (1127–1279)
Fan mounted as an album leaf; ink and color on silk
9⅜ x 9⅗ in.
The Metropolitan Museum of Art, New York,
John Stewart Kennedy Fund, 1913 (13.100.112)
Image copyright © The Metropolitan Museum of Art.
Image source: Art Resource, NY

Delight of Winter

January 29, 1979

The narcissus, to the Chinese, is the flower of the New Year. It symbolizes happiness and joy.

When frost brings the flowering portion of my outdoor garden to a temporary halt, I try, like many other people, to compensate by growing things indoors—and one of my most delightful compensations is the paper-white narcissus.

Just three bulbs, semimasked in pebbles and a fair amount of water, will develop into a joyous thing of beauty in a few short weeks. First come the lissome sprouts, which will develop into flaring elongated leaves. And barely visible among them, somewhat like a pale and narrowed Chinese peapod, the floral body starts its rise toward glamorous maturity.

And as every winter I enjoy my paper-white narcissus, I think of how many others, Americans as well as Chinese, also look to the same flower as a physically small but psychologically significant delight of their winter seasons.

The Chinese call the narcissus the Water Fairy, and they force it into bloom to coincide precisely with the New Year (which for them is January 28) for they believe it indicates good fortune.

It seems to me that the Chinese, especially, enjoy the flower because they enjoy it symbolically as well as physically, and because they enjoy it in a variety of presentations, artistic as well as actual.

The painting with which we illustrate the narcissus, from the collections of the Metropolitan Museum of Art, shows four slender leaves together with a cluster of small blossoms. It is a sparse and quiet, yet provocative, composition. Although painted anonymously, it bears on the lower left one seal of An Ch'i (1683–1742), an early Ch'ing collector.

The astute and highly regarded authenticator C. C. Wang feels that, in manner and brushwork, this could be one of Chao Meng-chien's famous narcissus paintings. Chao Meng-chien painted during the latter part of the Southern Sung dynasty (1127–1279).

The dainty flowers look almost personalized, as though they were little heads. One can almost hear them speak their New Year message. Almost childlike in their innocence and purity, they seem to capture the infancy of the year and lend it a buoyant presentation.

And then I think that, no matter how captivating the narcissus may be in and of itself, in art it may be even more so.

白雲如帶束山腰
磴飛空細路遙
杖藜舒眺望欲因鳴
澗苔吹簫沈周

SHEN ZHOU
Poet on a Mountain Top, from Landscape
Album: Five Leaves by Shen Zhou, One Leaf
by Wen Zhengming
China, 1496 (Ming dynasty)
Album leaf mounted as a handscroll; ink and
color on paper
15¼ x 23¾ in.
The Nelson-Atkins Museum of Art, Kansas City,
Missouri, Purchase of William Rockhill Nelson Trust
(46-51/2) Photo: John Lamberton

The Mountain in My Mind

July 25, 1978

Mountains, to the Chinese, are yang motifs. Strong and assertive, they stand for achievements and conquests.

I look up and out, across my little plot of land, to a moderate, high, bulging incline on my left. This, indeed, is my "mountain," in my landscape architecture. It might also symbolize any mountain, physical or mental, that I might have to climb.

It appears to me that what I call "the mountain" may exist not only in nature but also in my mind. The mountain in my mind may be ambition or achievement. And it may also be an obstacle or problem. Whenever I conquer my own mountain, be it a challenge or an obstacle, my conquest is achieved through the mental qualities of strength, power, and perseverance.

The concept of the mountain as both physical and spiritual has preoccupied Chinese artists and artisans since the dawn of time. Movements of sun and shadow-play on distant mountains have been cited as earliest incidences of yin and yang, observed in most ancient times, even before recorded history. Over the centuries, mountains have been fashioned in jade, in porcelain, in rock crystal, as well as in paintings. Always they are reminders of the Chinese belief in the yang essence of power as foil to the yin essence of softness.

In his painting of *Poet on a Mountain Top*, the great Ming-period master Shen Chou (1427–1509) shows a little figure as master of a great ascent. What matters if his mountain were physical or mental, actual or imaginary? All that matters is that he is on top of it, that he has triumphed; and in his triumph is his splendor of achievement.

This painting by Shen Chou is in itself a triumph, both linear and conceptual. It is not only superb from the point of view of draftsmanship and brushstroke. It is also provocative, tender, and of immense psychological relevance. Reminding us all of our potentials, and yet at the same time giving full credence to our seeming slightness, *Poet on a Mountain Top* is in itself a mountain in the history of Chinese art—as Shen Chou also is in his own right.

Nor is *Poet on a Mountain Top*, or Shen Chou, relegated only to art history. It inspires the present-day creativity of Ma Pai-Sui, eminent Chinese artist now living in New York. Mr. Ma transcribes the small black-and-white original of Shen Chou into a huge colorful semiabstraction, adhering to the original design but dramatizing it with the color and size of modern concepts.

"I turned the poet into a lighthouse," Mr. Ma smiles quixotically. "Both 'poet' and 'lighthouse' are characterized by brilliant brightness and great farsightedness and breadth of clarity."Going on to discuss his painting, Mr. Ma continues, "This painting I have done in watercolors, and I often also use acrylics. The superimposed wood stripping on this picture subdivides the overview into a series of smaller pictures. Although I use American materials, I still consider my style that of a Chinese artist."

Can I not be a "poet" and climb the biggest heights? And may not my own "mountains" be also in my mind? And can I not place myself on top of it, whatever it is, as Chinese artists have done for centuries, from Shen Chou to Ma Pai-Sui?

HU ZHENGYAN (HU CHENG-YEN)
**Pine Tree and Rocks in Circular Fan Shape, from *The Ten Bamboo Studio Manual
of Calligraphy and Painting (Shizhuzhai shuhua pu)***
China, ca. 1633–1703
Page from a woodblock-printed book mounted as an album leaf; ink and color on paper
9¹³⁄₁₆ x 11⁵⁄₁₆ in.
Harvard Art Museums/Arthur M. Sackler Museum, Francis H. Burr Memorial Fund (1940.165.123)
Photo: Imaging Department © President and Fellows of Harvard College

Friends of Winter

March 4, 1976

The pine, to the Chinese, is for all seasons. It stands for strength and courage.

I have around my home several pines of varying shapes and sizes, many of which I bought many years ago, and all of which I have seen mature. Like children, they once were babies, and now they have taken on personalities of their own: There is a snobbish one out on my porch, somewhat like an elongated bonsai, its snout aloft courting a strong sun. Down around the pool, there are little fellows, which I have trained to cascade horizontally, and flit across the very surface of the water. And the Number One Pine, to the rear, which I purchased many years ago at a slim size and price, today turns and twists above my head in towering proportions.

What is the mystique of the pine? The Chinese have a saying that the pine stands for strength because it weathers the cold winter and does not even lose its leaves.

In the growing season—that is, in the spring, summer, and the fall—the pine is for me a source of invariable delight, with the perky crispness and spikiness of its needles.

But it is in the winter, it seems, that the pine comes into its full glory. In the very heart of wintertime, it lends brilliance to my garden. It grips little powder puffs of snowflakes, and it retains icicles after storms to shine like prisms in a dazzling sunlight.

However, it is not only from the point of scenic loveliness that the pine is outstanding in the winter—it is also in the wintertime that its philosophical implications acquire their magnitude.

Sometimes I go out into my garden on a snowy day, enjoying the clean effects of all the land turned white, and catch my breath at the indomitable little pines—their needles sharp, staccato, and unblemished, their branches trudging bravely through the snow. I look around at all the other high oak trees, their branches barren now of leaves whittled away by winds and rains. And suddenly I see my pines with humility and admiration.

Do I always manage, in my "wintertime"—personal or chronological—to "hold on to my leaves"? To keep myself intact? To stand against the storm?

Along with the bamboo and the prunus, the pine has long been known to the Chinese as one of the three "Friends of Winter." The Chinese have used the motif in countless art works—in paintings, as well as in porcelains and jades—to remind themselves that, in the hard, bleak days of wintertime which no one can escape, when "fair-weather friends" have gone astray, the pine and its associates are remaining strong and stalwart.

Can we not, too, look upon the pine and see—in the way it retains its leaves—not only a symbolism of great strength but also something of an inspiration for our own "wintertime"?

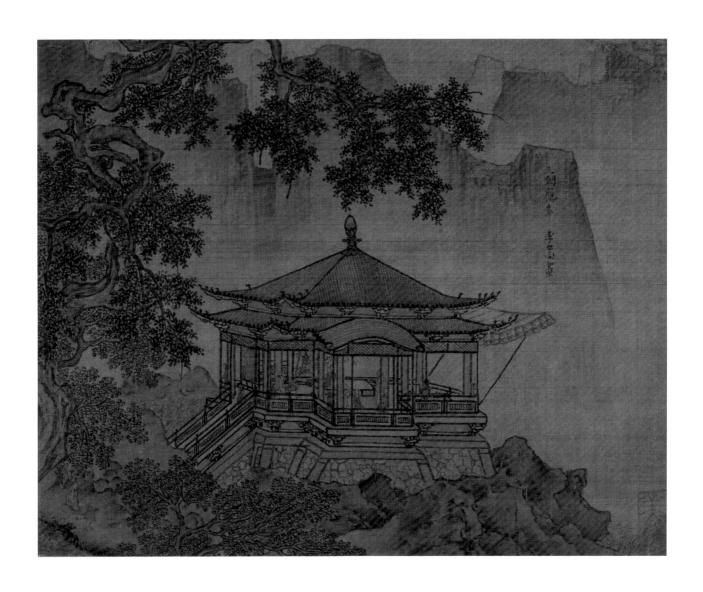

UNIDENTIFIED ARTIST
A Pavilion
China, Southern Song dynasty (1127–1279)
Album leaf; ink and color on silk
7 x 8¼ in.
The Cleveland Museum of Art, Gift of the John Huntington
Art and Polytechnic Trust (50.1915)

Borrowed Scenery

February 21, 1984

The Chinese have an unusual, and I think sensible and rewarding, attitude, which goes by the name of "borrowed scenery." "Borrowed scenery" refers to portions of the landscape that extend beyond the confines of one's own property and add to it both geographical and psychological extensions.

I was recently reminded of the Chinese concept of borrowed scenery in the garden of my home. A neighbor to the south had put up, on a downward slope of grass and trees, a slight, green umbrella type of structure, much like what the Chinese call "pavilion." It blends into the surrounding vista and lends a new dimension to my world.

When I look down and out to my pavilion, I sense an instantaneous projection of myself into that pavilion, wherein, in its woodsy setting, I am aware only of myself and nature.

This recent acquisition is as much mine as it would be if it were really mine. It is mine to look at, mine to enjoy, mine to meditate upon, and mine through which to achieve a totally fresh perspective on my garden.

The pavilion has long been a device, in the Chinese landscape and in Chinese landscape painting, both to represent man and to offer man a spot wherein he can meditate in natural surroundings upon his place in nature. The pavilion shares identical appearance with the thatched hut from which it is distinguished by certain minor details of architecture.

Countless artists apart from Wen Cheng-ming of Ming times have frequently depicted the pavilion in their paintings. They range from Ni Tsan (1301–1374), a great major landscapist of the Yuan dynasty (1279–1374), who used the pavilion almost as his signature in his sparse, unhurried river views, to many artists of today.

I think the pavilion, with its neat, classic, linear shape, fits deftly and ideally into the pattern of the landscape, with its curvilinear design. It is modest and unassuming like the Confucian gentleman, and it is sparse and spare.

Prior to my own recent acquisition, my most dramatic encounter with the pavilion as borrowed scenery took place several years ago, when I was shown into a hotel room at night in Taipei. A Chinese-red pavilion was softly illuminated in the out-of-doors and just beyond my window. It greeted me with a shock of surprise and with its dazzling beauty. It immediately, and by association, turned my mind to nature and to my involvement with all of nature.

But borrowed scenery is by no means limited to the pavilion. It can and often does consist of land- and waterscapes. I have a bedroom window that overlooks a neighbor's swimming pool, which, softened by some trees, moves into my consciousness and becomes my lake. I have a friend in California whose garden has an overview of distant hills, which lend enchantment as well as depth and width and height to her own terrain, and are indeed borrowed scenery. Finally, what about the fortunate few whose overlook is of "their" bay, "their" lake, or "their" ocean?

UNIDENTIFIED ARTIST
Birds and Ducks on a Snowy Islet
China, Southern Song dynasty (1127–1279)
Album leaf; ink and slight color on silk
10 3/16 x 9 5/8 in.
The Cleveland Museum of Art, Gift of the Women's
Council of the Cleveland Museum of Art (1961.260)

The Bird upon the Branch

July 19, 1976

I often sit out on my porch and look at a favorite dogwood tree, which is slim and elegant, and strangely satisfying with its balanced conformation. Frequently a bird pauses on a branch and perches there, as though immobilized.

With a sudden shiver of delight, I become riveted as I observe the bird upon the branch. Not only is it lovely in itself, it perpetuates a long tradition. Even more, it epitomizes timelessness—in my own time.

The Chinese emperor Hui-tsung (1101–1155) was fond of painting birds upon a branch. Hui-tsung's affection for bird painting gave rise to a whole new school of Chinese painting, and his paintings have found their way into most eminent collections. As patron of the arts, Hui-tsung encouraged all sorts of Chinese painting, but when it came to his own forte, he found it in the painting of the birds.

What was so intriguing to Hui-tsung, I wonder, about the bird upon the branch? And why is the same vision of such delight to me in my own time?

I feel that I am drawn to the bird-upon-the-branch for various reasons. One is the simplistic notion of disparity of size. I feel that I am so large and that the bird by contrast is so small.

Then I have in the bird the implicit notion of a sense of freedom. The bird alights wherever he wants. He is "free as a bird." He seems to have no work to do, other than garner his own worm.

But most importantly, there is something for me of the ancient yin-yang contrast in the spectacle of the bird upon the branch. There seems to be something in the relationship of the straight line of the branch to the curvilinear design of the bird which is immensely gratifying. The little bird, with its rotund fluff of head and body, rests in a compensatory fashion upon the abbreviated dash of a branch. Here we have, in a sense and at a glance, the eternal compatibility of the opposites.

Softness is here, in the bird, together with the hardness of the branch. Implications of impermanence are here, in the bird, as contrasted with the comparative permanence of the branch. Suggestions of dazzling mobility are here, in the bird, as contrasted with the static nature of the branch.

I know, as I observe my bird, that the sense of compensatory values is a fleeting one. The bird will fly away and the entire configuration is lost. But for now, just for now, in the brief instant that the bird appears upon the branch, my vision of the philosophical reality and of the unity of the opposites is complete and total.

Long have I looked with wonder upon a bird upon a branch. And now I know the reason why. The interrelationship of the bird upon the branch seems to bring together all of life, and to synthesize its myriad contradictions.

The Flower That Welcomes Spring

March 13, 1979

The first spring flower—after the crocuses and earliest bulbs—appearing in my garden is the magnolia.

It opens its luxuriant flowers wide and white and waxen. It is the stellata variety, or earliest blooming type, and when brought into the house, a few sprays present an elegance of kingly ransom.

My magnolia is positioned in the garden directly behind a forsythia bush, which comes into flower at the same time, with its yellow spiky blossoms contrasting well with the velvety-textured white magnolia. The combination of the two, far to the rear of the garden but ever so eye-catching, with a bravura of coloristic opulence, spells "spring."

Wen Cheng-ming, in his handscroll of the magnolia from the John M. Crawford collection in New York, gives us, above all else, the waxen character of the magnolia. As if by magic, he depicts its extraordinary character, its textural depth, and its opulence.

I can well imagine Wen Cheng-ming (1470–1559), master of the Wu School of Chinese painting, of an evening in his hometown of Soochou. After dusk, he is supposed to have gathered about him his disciples and his colleagues—to paint, to write poems in calligraphy, and to relax in a manner befitting the artistic lifestyle.

I think back to the lovelinesses of this earlier era, of the Ming dynasty in China (1368–1644). I conjure up the famed terrain of Soochou, which was then the art center. And I also conjure up the exquisite surroundings, which include the Ming furnishings, in which the artists worked.

It was probably in such a setting, simplified and elegant beyond compare, that Wen Cheng-ming painted his *Magnolia.* The early type of flowering magnolia, shown here and which we call "stellate," is known to the Chinese as "Ying Ch'un Hua," or "Flower That Welcomes the Spring," because of the fact that its large white flowers appear on the plant before the leaves.

The treatment by Wen Cheng-ming of the magnolia as a handscroll is, in itself, provocative. The handscroll, opening up horizontally, as it does, from right to left, creates a foray into time and place, from bud to full-blown flower . . . now perky, now wilting, now open, now compressed.

And how do these sequential changes in the magnolia differ from the changes that we all share?

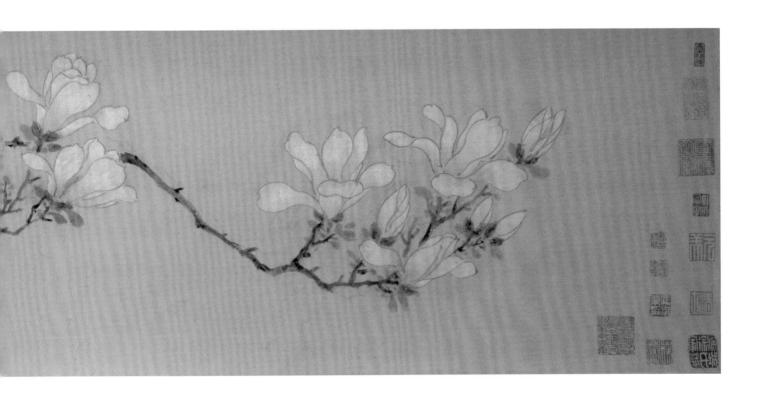

UNIDENTIFIED ARTIST
Magnolia
China, 1549
Handscroll; color on paper
The Metropolitan Museum of Art, New York
(1989.363.64)
Image copyright © The Metropolitan Museum
of Art. Image source: Art Resource, NY

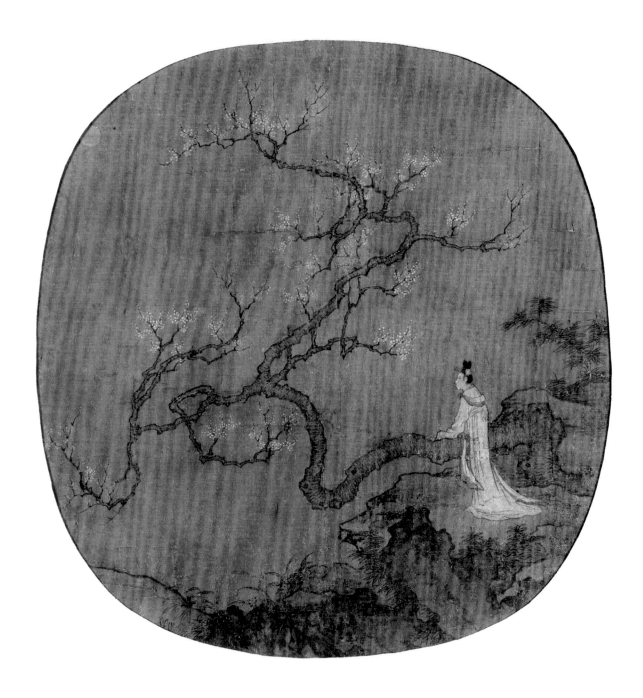

UNIDENTIFIED ARTIST
Lady Leaning against a Blossoming Plum Tree
China, Yuan dynasty (1279–1368)
Circular fan painting mounted as an album leaf; ink and light colors on silk 9¼ x 9 in.
Harvard Art Museums/Arthur M. Sackler Museum, Gift of Philip Hofer in honor of Agnes Mongan
(1971.58.1)
Photo: Imaging Department © President and Fellows of Harvard College

China's Tree of Strength in My New York Garden

March 27, 1985

For many years, I have been inspired by the plum blossom, the small, five-petaled, white flower which, because it is winter-blooming, is considered by the Chinese to stand for strength and courage.

Whenever I encounter it—in Chinese painting, poetry, jade, or textiles—it impresses me, despite its diminutive size, with the marvel of its message. One of the ancient symbols in Chinese thought, the plum blossom has a distinguished history. And wherever I run into it, it proffers the same wisdom. "Be strong," it seems to say. "Flower, as I do, in the winter time, in your winter time."

Suddenly, a few years back, I became eager to place a plum tree in my garden. I wanted to enjoy its blossom in nature, as well as in art. After unsuccessfully combing the nurseries of the eastern United States in search of one, I was overjoyed to come across it in a nursery in the West, down the road from my native San Francisco.

It was not surprising to find it there, since the month of February lines the streets and roads of northern California with plum trees—their purplish leaves a brilliant foil to the dainty flower.

Featherlight and packed in dry root, the small sapling accompanied me on the plane back to my New York home. I planted it, watered it, and watched it grow at a slow but steady pace. I looked forward to the time when, flower laden, it would present in actuality what countless artists have portrayed in art.

So long a devotee of the plum blossom, I was fascinated recently to come across one of the most beautiful paintings of it that I have ever seen. It was hanging in a corner of the Fogg Museum at Harvard University. It is entitled *Lady Leaning against a Blossoming Plum Tree* and, for several reasons, it appears extraordinary. It is anonymous. It yields remarkable artistic satisfaction, with its effect deriving in part from the union of opposites. The twisting format of the tree seems to balance the structural simplicity of the figure.

It also seems that the painting, though done in the Yuan dynasty (1279–1368), is as modern as tomorrow. Often I've leaned, mentally if not physically, on a plum tree (or a bamboo or a pine, cohorts of the plum as "Friends of Winter") for sustenance and for the great gift of serenity that nature provides.

The convoluted plum tree seems almost like a writhing dragon (symbol of power), while the lady—quiet, preoccupied, serene—suggests the sensitive scholar grappling with a problem and finding herself buoyed up by the blossoming plum.

One sunny morning, just this year, I walked out to my porch. I thought the sun was playing games with me. There were strange shadings on the plum tree. I walked over for a close inspection. The shadings were not the sun. They were plum blossoms. And in myriads of small, five-petaled clusters. They looked exactly like all the pictures I had long admired. I could not believe it. It was the moment I had hoped for, with wonder, with doubt, since I had, several years ago, carried the bare root with me, like an infant on the plane from San Francisco.

All the false alarms, all the trips I had made outdoors to gaze vainly upon it, all the disappointments I had had when buds flowered only into foliage, were forgotten. Now I look forward to the day when my plum may achieve mature gigantic turnings; and when I, too, may lean upon its strongest early branches with equanimity and poise.

Listening to and Learning from Water

October 13, 1977

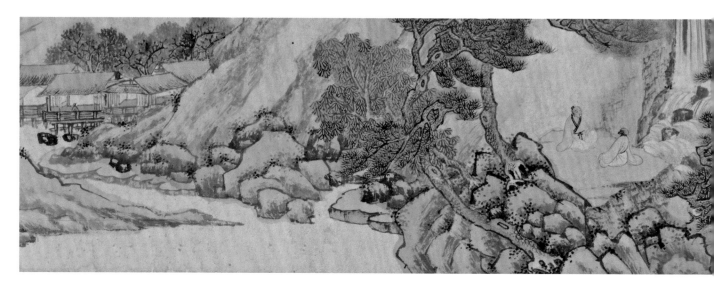

In his Tao Te Ching, *Lao-tzu refers to water as "having humility, and seeking always the lowest place."*

I wonder, do I "seek the lowest place" —or the highest? Do I subordinate myself or do I seek to stand out and to shine? Do I practice humility, or am I not offensive, with arrogance? Do I really, in the confines of my heart, partake of the "humility" of water?

I have a little handscroll on my desk. And I often rest on the first stanza of it, to regard again that waterfall, the narrow ribbon of a liquid bounty, which does, indeed, fall to the lowest place. And in my beloved garden, I see, year round, evidence of the fact that water does, indeed, seek the lowest place. It drops, over a flat rock, into a pool. (Never does it rise.) It falls, through a procession of brooks, into other little pools.

(Never does it go against the force of gravity and seek its own ascension.)

It culminates, finally, in the lowest posture of the garden, in its largest pool, to be therein a focal point of beauty and of inspiration for all to see. It commands attention, in its lowliness; for it offers there, in the very pit of this minute horticultural universe, a lively elegance in its sparkle, originality in its

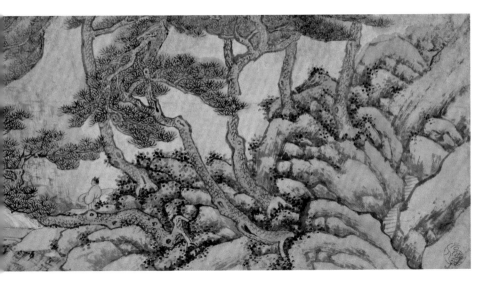

WEN ZHENGMING
Enjoying the Waterfall
China, 16th century
Ink and color on paper
12½ x 421 in.
Courtesy the
Iris & B. Gerald Cantor Center for
Visual Arts, Stanford University,

presentation, a call to thought in its relation to ancient Chinese wisdom.

Water, as the great yin principle, need not advertise itself. Need I? Water, as the great yin principle, shines from below . . . draws all attention to its lowly posture . . . inspires generations of Chinese with its spiritual symbolism of humility as based upon its low positioning.

Can I, like the water, see myself so low, so humble, that I can be morally on high at the same time? Can I see myself, like water, as so lowly and unimportant that my very sense of unimportance becomes, in itself, an important virtue?

Water, as symbol of the yin motif, is radical to Chinese landscape painting. It is the rest, the quiet, and the unobtrusive—as contrasted with the assertiveness of its counterpart, the rock or yang motif. Together, the two, the yin and the yang, make up not only Chinese landscape painting, but also Chinese thought, Chinese philosophy, Chinese lifestyle, and Chinese art.

If water is, indeed, the yin motif . . . if it occupies "the lowly place" . . . and if it, in so doing, represents humility as a commanding virtue, does it not serve my own best interests to try to follow suit?

UNIDENTIFIED ARTIST
Waves in the Moonlight
China, probably 13th century (Southern Song or Yuan dynasty)
Circular album painting mounted as a hanging scroll; ink and
gold on silk; Diam. 12 in.
Harvard Art Museums/Arthur M. Sackler Museum, B.A.G.
Fuller Bequest Fund (1961.63)
Photo: Imaging Department © President and Fellows of
Harvard College

Water Stronger than Rock

April 20, 1976

One of the most intriguing aphorisms of the philosopher Lao-tzu is his observation that water, though most soft, has the strength to crush the hardest rock.

Mindful of the validity of this comment, which has since time immemorial given countless generations of Chinese vast food for thought, I meditate upon the water as I see it in my garden pool, in lakes and rivers, and even at the ocean. I find in water not only a general serenity, which connotes a very special timelessness, but also a new immense significance in its every contact with a rock.

And I am reminded of the geologic factor of erosion, whereby the soft and porous texture of the water has indeed worn away the hardest rock, and changed in our real landscape the very contours of our land.

This water, which crushes hardest rock, what can this mean to me?

Should I not be able to exercise the fluidity of water, and be able to exert its force to combat any "rock" or obstacle in my way? And should I not be able to employ its gentleness against any demon, actual or imaginary, which appears to be a cruel rock within my course?

It seems to me that in the spiritual or psychological realm, the same results can take place as in the physical, and that "water" can indeed triumph over "rock"; that is, that gentility or kindliness can triumph over arrogance or hostility. And this is precisely what I understand to be the meaning of Lao-tzu in his unforgettable quotation.

I feel that Lao-tzu has given me a valuable lesson in interpersonal conduct, as well as setting guidelines for me in the conduct of my life.

Water is as important to Chinese landscape painting as oxygen is to the air we breathe. To describe the extraordinary complex of Chinese landscape painting, which is at once aesthetic and philosophical, the Chinese have a word, *shan-shui*, which means "water-rock" (or, more strictly, "mountain-water") painting.

Water is the yin principle, both in Chinese thought and in Chinese art. It is soft. It counterbalances the "rock," which embodies the hardness and assertiveness of the yang principle.

In the fifth century B.C., the time of Lao-tzu, I would guess that his implication was in the nature of advice to his contemporaries. His was a time of tension, strife, and anarchy. It also was a time of civil war. Somehow it seems probable that Lao-tzu, philosopher of wilderness and protagonist of man as part of nature, would have suggested, as a way to forgo violence, that man see himself as soft and yet at the same time as potentially effective as the water.

Do I, in my own life, give proper credence to that water which is, incidentally, so much a part of my own self? Do I always realize in my dealings with my family and my friends, in my relationships to my inferiors as well as my superiors, that I am most likely to have good fortune on my side if I conduct myself softly as the water?

The Artist as Fisherman

May 5, 1977

The Chinese have a symbol for the fisherman who appears so often in the Chinese paintings. They think of him as the hermit-scholar... apart from the crowd... alone but not lonely... feeling himself attuned to the processes of nature.

And sometimes, I wonder, am I not also a "fisherman" as I strive to gain contentment and understanding in my life?

Sometimes I sit down on a big flat rock, which abuts a garden pool, and listen to the drip-drip of the water as it falls with quiet measured cadence into the pool. I think of the great back-to-nature movement, which has, under the name of Taoism, for so many centuries fascinated and motivated the classic Chinese lifestyle. And I think that "fishing" in nature for serenity is no monopoly of the Chinese, nor indeed of any century, and that it is my prerogative, as well, to be a "fisherman."

And sometimes I think of an eleventh-century Chinese poem, written by Huang T'ing-chien (1045–1105), which has recently preoccupied the eminent Chinese scholar and Taiwan Palace Museum advisor, Leon Chang. The poem in translation is something like "Fishing on the terrace / the shocking sound of water / produces daytime sleep." Is not the comprehension of this eleventh-century poem strangely paralleled today, in my own experience? Is it not

my mind that is "fishing," my rock that is "the terrace," my diminutive cascade that is "the sound of water," and my reward, a relaxed and easy mood?

The concept of the fisherman as a Taoist symbol first came into existence in the fourth century B.C., at which time the earliest poem on this theme appears in the *Ch'u tz'u* anthology. In Chinese painting, it makes its first appearance in the T'ang dynasty (618–907).

The concept of the fisherman as the contented lone recluse gained sharp acceleration from the thirteenth-century Mongol invasion, which brought in its wake a dislike for art and artists. The artists, having no choice, escaped into the countryside. They depicted themselves, and thought of themselves, as fishermen, as hermits who had given up the worldly life.

In both Chinese painting and in Chinese poetry, the fisherman theme perseveres at least throughout the eighteenth century, and most probably to modern times.

In modern times, I wonder if it may not be I who happens to be "hooked," and if I may not be at once the fisherman and the fish?

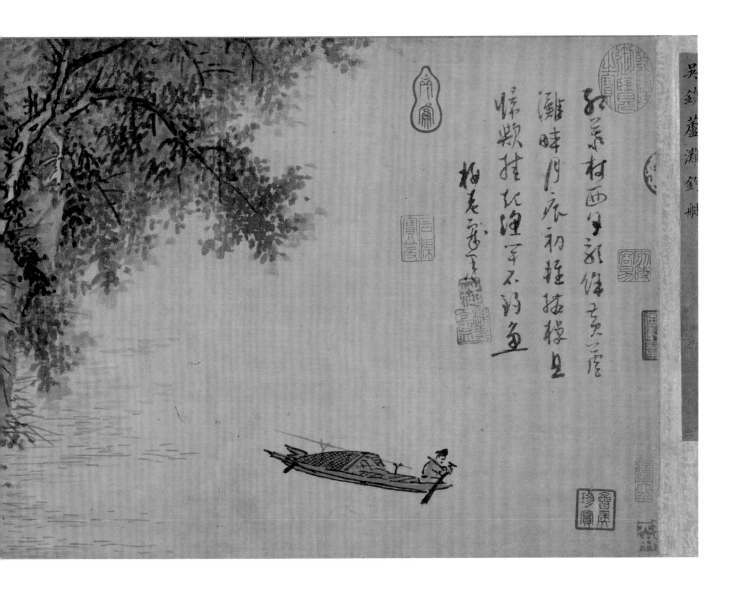

WU ZHEN
Fisherman
China, ca. 1350 (Yuan dynasty)
Handscroll; ink on paper
9¾ x 17 in.
The Metropolitan Museum of Art, New York, Bequest of
John M. Crawford Jr., 1988 (1989.363.33)
Image copyright © The Metropolitan Museum of Art.
Image source: Art Resource, NY

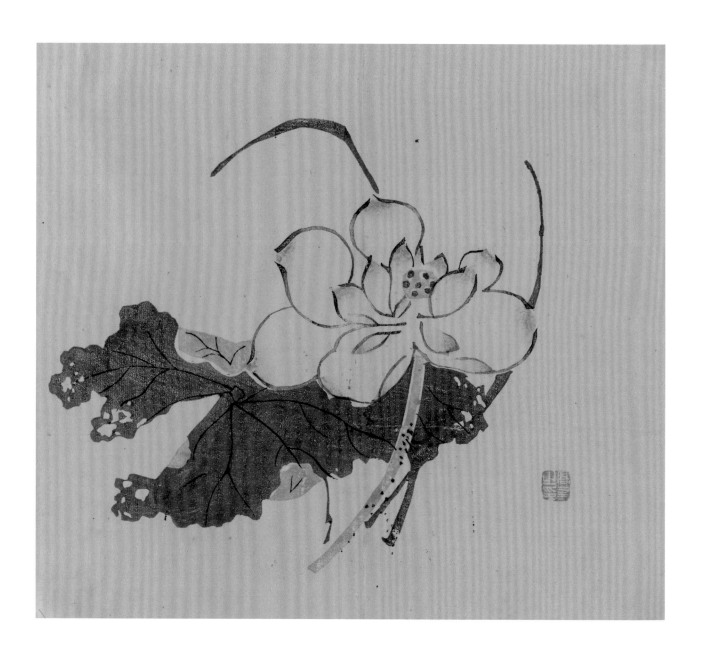

UNIDENTIFIED ARTIST
Lotus Blossom
China, Ming dynasty (1368–1644) or later
Color woodblock print
9¹⁵⁄₁₆ x 11⁹⁄₁₆ in.
The Cleveland Museum of Art, Edward L.
Whittemore Fund (1941.282)

The Serenity of the Lotus

November 8, 1977

The Chinese feel that the lotus represents both purity and serenity. And further, they feel that it is an example of the cyclic onward march of nature.

I have positioned on my desk a small white porcelain brush pot. It is rectangular. It is carved in openwork, so that in the evening as it is placed beneath a reading lamp, it takes on shadows and silhouettes, which give it a breathtaking monumentality. Three sides depict a walled garden, with flowers and foliage tumbling over garden walls.

But the fourth side—and it is the fourth side which is so expository and so meaningful to me—can be seen as the transposition of a limpid pool in summertime. It also can be seen as the total lifespan of the lotus. Buds or "pods" are there. So is the waxen flower in its maturity. So, also, is the narrowed elongated finale of the bloom.

But in addition to the depictions of the flower is one dramatic and, to me, captivating leaf, which bisects curvaceously almost one third of the surface. It is delicately veined and symmetrically scalloped.

It is the leaf that attends the total lifespan of the lotus, I remind myself, as I observe the centrality of its position.

The leaf is also somewhat of an extension of the flower—that which antedates it and survives it. And then I remind myself that, to the Chinese, all parts of the lotus plant are sacred—leaf and stalk and root, as well as flower.

The high esteem in which Chinese artists hold the lotus reverts back to the Han dynasty (220 B.C.–A.D. 220), with the introduction into China from India of Buddhism. The Buddha, in his moment of "enlightenment," is supposed to have seen all persons of the world as a sea of lotuses—perfectible, chaste, all-pure in their attitudes and characters, even as the lotus itself attains pure beauty, though emerging from the mud.

Quite independent of Buddhism, the indigenous Chinese philosophy of Taoism, which together with Buddhism relates man to nature, had conceived the concept of the lotus as a symbol of serenity. And how quiet, serene, and elegant the lotus is, in fact, as it floats motionless above the surface of the water.

Among contemporary Chinese artists specializing in the painting of the lotus (and one who learned her craft from Chang Ta-ch'ien, senior statesman of the Chinese art world), is New York–based Diana Kan. Diana Kan, in her frequent exhibitions around the world, and in her recently published book, *The How and Why of Chinese Painting*, gives constant and variegated exposure to the painting of the lotus.

With lively brushstroke, and with dramatic alternation of the wet brush and the dry brush, and with almost theatrical contrasts of black and white, Diana Kan presents her lotus as her philosophy—now bud, now leaf, now flower, now seed pod again—in the gentle indomitable onward march of nature.

It is not the lotus per se which so much intrigues the Chinese artists. It is equally the individual's own identification with the lotus, in all its symbolism.

If the lotus has purity and serenity, as well as constant change, do I not, myself, have access to these aspects also?

They Played My Song

July 2, 1984

I sit in the ingratiating sun of San Francisco, basking on the balcony of a newly inherited apartment in my hometown, and all my past takes on immediacy.

From my aerie on top of Russian Hill, I look down to Nob Hill, where the mansions of the early California nabobs have given way to hostelries that still sport their names.

There is the Huntington, where Grandma lived and where, for years, I looked forward to Friday night dinners and Baked Alaska, that gooey cream-puff confection of ice cream, cake, and egg whites, that was of such natural appeal to a child.

There is the Fairmont, where I danced away the night. Where the orchestra leader greeted my arrival with my theme song, "I've Got You under My Skin." Where I reserved for four dollars a room for a "very important guest" from New York, who was later to become my husband.

There is the Mark Hopkins, where I visited with girlfriends in late afternoons in the Peacock Court; and where Gertrude, on her annual visits from New York, awoke my love of music, which was to become a mainstay of my life.

And there is the Francesca, which was my home as a Stanford coed, a budding journalist, a radio neophyte, and a tennis devotee; and, then also, where I was married, in my mother's apartment, to my "very important guest" from New York.

My aerie of memory makes experiences from those days so lively that they feel as of this morning. Such as a blind date with a young author, who I thought had delusions of grandeur when he spent the evening telling me, "Someday the world will know the name Saroyan!"

In the foreground of my city view are rows of tidy little houses, gay and cheery in variegated colors, each with its bay window typifying classic San Francisco residential architecture. This is a throwback to many years of living in similar bay-window houses on Arguello Boulevard, Sacramento Street, California Street, and Jackson Street. And when I look out at the view, I think of the many friends with whom I have shared it, and still do.

I think that I might be less aware of the central focus as "my" San Francisco—my romantic experience of an earlier day—were it not presented in dramatic contrast to the "new" San Francisco, as seen in the grouping of today's skyscrapers. Somehow the juxtaposition sharpens both the time frame and my recollection and puts them in perspective. And although many here decry "Manhattanization," somehow in San Francisco, skyscrapers do not bother me. In fact, I find great style in the San Francisco skyscraper cluster, perhaps because of the uniquely designed Transamerica tower.

Not only by its shape, but also by its positioning, importance, and slender loft, the Transamerica tower somehow reminds me of the central pagoda in Kathmandu, Nepal—which again lends great individuality to the downtown section of a city.

Seductive as is my San Francisco view by day, by night, it is even more so. Then, it is flagrantly compelling. It is at least theatrical, as countless lights emblazon a nocturnal stage. I look out at the chic new crowning turret of the Fairmont tower, its top hat rakish like a Moorish fez. I survey the whole bedazzling entirety. And I wonder at the wisdom of my ancestors for having chosen this extraordinary locale for their lives and for my delectation.

The old and the new—Columbus Building and Transamerica Pyramid, San Francisco
Angus McComiskey / Alamy Stock Photo

Chinese Dynasties: Timeline of Illustrations

Pinyin Conversion Table

Most Chinese proper names and terms in Mary Tanenbaum's articles, such as personal and geographical names, book titles, and historical periods, are spelled in the Wade-Giles system which was popular in her times. To provide convenience to today's readers who are more familiar with the Pinyin system, the official transliteration system for the Chinese language adopted by most countries since the 1980s, the table below converts those names into Pinyin spellings as well as Chinese characters.

Wade-Giles	Pinyin	Chinese characters
Canton (city)	Guangzhou	廣州
Ch'ang-an (boulevard)	Chang'an	長安
Ch'ien Hsuan (artist)	Qian Xuan	錢選
Ch'ien Lung (emperor)	Qianlong	乾隆
Ch'iu Ying (artist)	Qiu Ying	仇英
Chekiang (province)	Zhejiang	浙江
Ch'ing (dynasty)	Qing	清
Ch'ing Ming (festival)	Qingming	清明
Chuang-tzu (philosopher)	Zhuangzi	莊子
Chu-ta (artist)	Zhu Da	朱耷
Fan K'uan	Fan Kuan	范寬
Han (dynasty)	Han	漢
Han Lin Hua Yuan (institution)	Hanlin huayuan	翰林畫院
Hangchou (city)	Hangzhou	杭州
Hsia Kuei (artist)	Xia Gui	夏珪
Hsiang Sheng-mo (artist)	Xiang Shenmo	項聖謨
Huang T'ing-chien (poet)	Huang Tingjian	黃庭堅
Hui-tsung (emperor)	Huizong	徽宗
I Ching (book)	Yijing	易經
K'ang Hsi (emperor)	Kangxi	康熙
Kao-Tsung (emperor)	Gaozong	高宗
kao yuan (far view)	gao yuan	高遠
Kiangsi (province)	Jiangxi	江西
Kiangsu (province)	Jiangsu	江蘇
Ku K'ai-chih (artist)	Gu Kaizhi	顧愷之
Kweilin (city)	Guilin	桂林
Lao-tzu (philosopher)	Laozi	老子
Li (river)	Li	灘
Li Ch'eng (artist)	Li Cheng	李成

Li K'o-jan (artist)	Li Keran	李可染
Lin Yin (temple)	Lingyin	林隱
Liu Kung-ch'üan (artist)	Liu Gongquan	柳公權
Lu Chih (artist)	Lu Zhi	陸贄
Lungmen (cave)	Longmen	龍門
Ma Lin (artist)	Ma Lin	馬臨
Ma Yuan (artist)	Ma Yuan	馬遠
Mi Fu (artist)	Mi Fu	米芾
Mi Yu-Jen (artist)	Mi Youren	米友仁
Ming (dynasty)	Ming	明
Nanking (city; road)	Nanjing	南京
Ni Tsan (artist)	Ni Zan	倪瓚
p'ing yuan (near view)	ping yuan	平遠
Peking (city)	Beijing	北京
Shan-shui (mountains and waters)	Shanshui	山水
Shang (dynasty)	Shang	商
Shen Chou (artist)	Shen Zhou	沈周
Soochou (city)	Suzhou	蘇州
Ssu-ch'uan (province)	Sichuan	四川
Sung (dynasty)	Song	宋
T'ang (dynasty)	Tang	唐
T'ang Yin (artist)	Tang Yin	唐寅
T'ao Yuan-ming (poet)	Tao Yuanming	淵明
t'ao-t'ieh (bronze vessel)	taotie	饕餮
Tao Te Ching (book)	Dao de jing	道德經
Tao-chi (artist)	Daoji	道濟
Tsuan Tsung (emperor)	Xuanzong	玄宗
Tsung Ping (artist)	Zong Bing	宗炳
Tung Ch'i-ch'ang (artist)	Dong Qichang	董其昌
Wang Wei (poet)	Wang Wei	王維
Wei (dynasty)	Wei	魏
Wen Cheng-ming (artist)	Wen Zhengming	文徵明
Wen T'ung (artist)	Wen Tong	文同
Yang (concept)	Yang	陽
Yen Ts'u-yu (artist)	Yan Ciyu	閻次于
Yin (concept)	Yin	陰
Yuan (dynasty)	Yuan	元
Yung Lo (emperor)	Yongle	永樂

Index

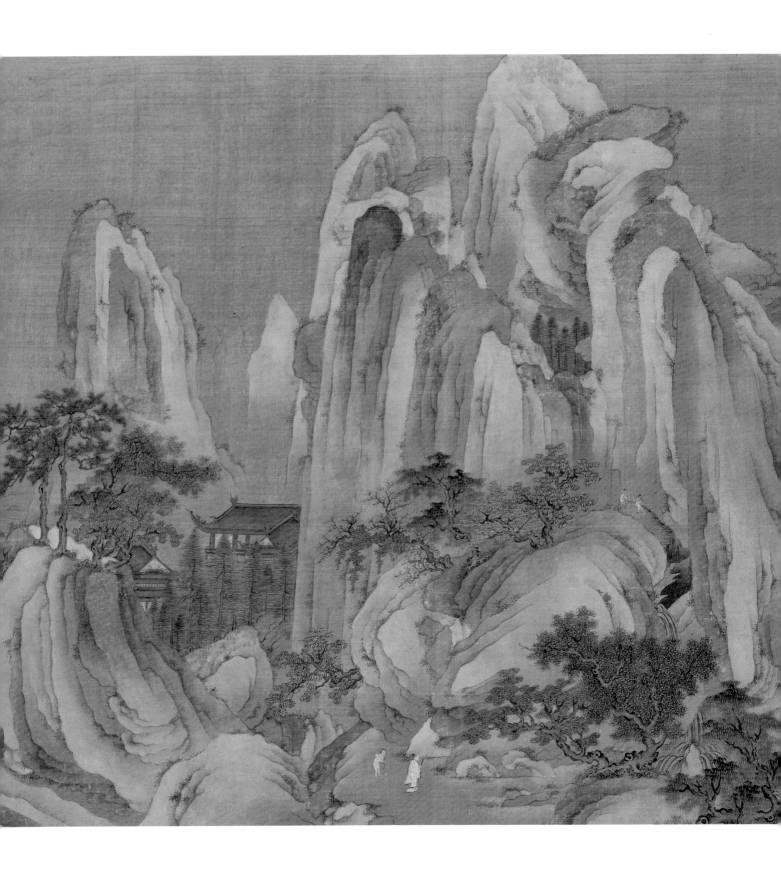

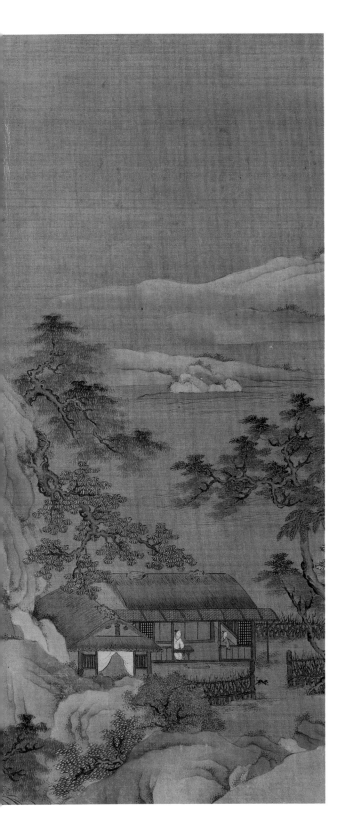

Acknowledgments

Ann Tanenbaum and I wish to share publicly our appreciation for all those people and institutions without whose help this book would not be possible.

Michael Keller, your support and guidance have been invaluable. We are deeply indebted to you for piloting this project toward completion.

To those at the Stanford University Libraries who consulted with us and gave so freely of their time and energy, we extend our thanks: Peter Blank, Chris Bourg, Becky Fischbach, Alan Harvey, Sonia Lee, John Mustain, and Jidong Yang.

To their counterparts at the Iris & B. Gerald Cantor Center for Visual Arts at Stanford, we give further thanks: Alison Akbay, Tammy Fortin, Noreen Ong and Mona Duggan, for her enthusiasm and guidance on the eve of her retirement.

Ellen Nygaard, for going above and beyond book designer, thank you. Your instincts, talent and experience made this process a pleasure. Livia Tenzer, thank you for your eagle eye when it came to copyediting. And, Eileen Quam, thank you for organizing the information in Mary's articles into an easily consulted index.

For permission to reproduce Mary Mayer Tanenbaum's articles as they originally appeared, we wish to thank the *Christian Science Monitor*. We are particularly grateful to Ed Blomquist, who facilitated the use of the articles.

For permission to reproduce illustrations, we wish to express our indebtedness to the following institutions: Cleveland Museum of Art; Corbis; Colorado University Art Museum; Dayton Art Institute; Detroit Institute of Arts; Freer Gallery of Art and Arthur M. Sackler Gallery, Smithsonian Institution, Washington, D.C.; Harvard Art Museums, Cambridge; Iris & B. Gerald Cantor Center for Visual Arts at Stanford; J. B. Lippincott Company; J. Paul Getty Museum Open Content Program; Metropolitan Museum of Art, New York; Museum of Fine Arts, Boston; The Nelson-Atkins Museum of Art; Princeton University Art Museum.

For his tireless support and many efforts in making this book a reality, our special thanks go out to Bruce Crawford.

IN THE STYLE OF ZHAO GAN (FIVE DYNASTIES)
Landscape
19th-century copy (detail); Handscroll; ink, paper, and silk
15¼ x 182 in. image area. Collection of Ann Tanenbaum
Photo: Jeff Wells/CU Art Museum

A Note on the Text

The following are copyrighted by and reprinted with permission from *The Christian Science Monitor*:

"Art Replacing Nature" Aug 13, 1974
"Bewitched by Bamboo" Oct 15, 1974
"The Stone of Heaven" Feb 19, 1975
"The Moon, Seen Afresh" Mar 31, 1975
"Against the Tide" May 15, 1975
"Those Quiet Spaces In-Between" May 21, 1975
"What Do I Do When I Am Doing Nothing?" Aug 19, 1975
"Emperors and Friendly Dragons" Sep 09, 1975
"A Paragon of Order" Nov 19, 1975
"An Ancient Alliance" Jan 14, 1976
"Friends of Winter" Mar 04, 1976
"The Beauty of One Line" Mar 11, 1976
"Painting Is Poetry" Apr 14, 1976
"Water Stronger Than Rock" Apr 20, 1976
"The Bird upon the Branch" Jul 19, 1976
"The Art of Order" Aug 05, 1976
"The Longest Steps" Oct 05, 1976
"Beauty of Clouds" Dec 16, 1976
"The Tree in Winter" Jan 19, 1977
"A Winter Transformation" Feb 16, 1977
"The Near View" Mar 01, 1977
"The Artist as Fisherman" May 05, 1977
"Rhapsody to Spring" Jun 10, 1977
"The Symbol of Summer" Jul 27, 1977
"Listening To and Learning From Water" Oct 13, 1977
"The Serenity of the Lotus" Nov 8, 1977
"Autumn's Flower" Nov 11, 1977

These selections have been copyedited for the sake of consistency and clarity. Punctuation and capitalization have been standardized according to the *Chicago Manual of Style*. Chinese proper nouns are spelled according to the Wade-Giles system which was standard at the time of original publication.

All interstitial essays at the beginning of sections represent previously unpublished work by Mary Tanenbaum. Chinese proper nouns have been spelled according to the Wade-Giles standard. These essays have been edited for content, as well as for stylistic consistency. None have appeared previously, in their entirety, as they do in this book.